Painting in Opaque Watercolor

Rudy de Reyna

PAINTING IN OPAQUE WATERCOLOR

Watson-Guptill Publications, New York
Pitman Publishing, London

Paperback Edition
First Printing, 1979

Copyright © 1969 by Rudy de Reyna

First published 1969 in the United States and Canada by Watson-Guptill Publications,
a division of Billboard Publications, Inc.,
1515 Broadway, New York, N.Y. 10036

Published in Great Britain 1979 by Pitman Publishing Ltd.,
39 Parker Street, London WC2B 5PB
ISBN 0-273-01387-4

Library of Congress Catalog Card Number: 69-12492
ISBN 0-8230-3775-4
ISBN 0-8230-3776-2 pbk.

Manufactured in U.S.A.

Edited by Judith A. Levy
Designed by James Craig

To my wife

Acknowledgements

I would like to express my debt and gratitude to all the students of the Famous Artists Schools, whose probing questions motivated this book.

Rudy de Reyna
Westport, Connecticut

Contents

Acknowledgements, 7
Opaque Watercolor and Other Media, 10
Materials and Tools, 11
Project 1: Achieving the Right Paint Consistency, 16
Project 2: Painting Flat Tones, 17
Project 3: Mixing Your Own Values, 18
Project 4: Painting Shapes in Various Tones, 21
Project 5: Wet Blending Tones, 22
Project 6: Painting Over a Graded Tone, 24
Project 7: Painting a Tree in Values of Gray, 26
Project 8: The Technique of Drybrushing, 30
Project 9: Drawing and Painting Rocks, 32
Project 10: Painting Water, 34
Project 11: Using Common Sense, 36
Project 12: Experimenting with Unconventional Tools, 38
Project 13: Frisketing and Other Imaginative Techniques, 44
Project 14: Painting the Human Head, 50
Project 15: Experimenting with Different Surfaces, 58
Project 16: Painting the Female Nude, 62
Project 17: Painting Hair, 68
Project 18: Painting Animals, 70
Project 19: Painting Folds and Patterns, 86
Project 20: Painting Children, 96
Project 21: Introducing Lettering, 112
Project 22: Painting a Still Life in Color, 128
Project 23: Painting a Landscape in Color, 136
Project 24: Painting a Figure in Color, 144
Project 25: Painting a Portrait in Color, 152
Index, 160

Opaque Watercolor and Other Media

Before I plunge into the subject of this book—opaque watercolor—it may be helpful if I take a moment to say something about the medium and compare it with other kinds of paint which may be more familiar.

The most widely used form of watercolor is transparent. It's like a sheet of colored glass. When you apply a layer of paint (called a wash) to a sheet of watercolor paper, you can see through to the white surface beneath, or you see through to the preceding layer of color. This obviously means that you've got to paint unerringly, without hesitation, without changing your mind; you can't make many corrections because just about everything you do will show up in the finished painting. You just can't cover things up with a fresh layer of paint.

Opaque watercolor—which comes in a variety of forms called designers' colors, gouache, or just plain opaques—is fundamentally different in that one layer of color *will* cover another. This means that you can build your painting more slowly, change your mind, make corrections, and develop a great many complex effects that won't work in transparent watercolor. On the other hand, both opaque and transparent watercolor dry quickly, allowing you to work rapidly, spontaneously, and decisively.

To the eye, opaque watercolor seems to have more weight, more solidity than the more evanescent transparent watercolor. Handled with skill, opaque watercolor has the kind of weight we associate with oils, though the surface of opaques is matte, nonglossy.

Unlike oil, opaques don't stay wet long enough to blend and produce the subtle gradations which only a slow drying medium will allow. Nor can you scrape out opaques—as you can oils—and start over again. But opaques *will* give you subtle gradations by other means—which I'll describe and demonstrate in the pages to come. And even if you can't scrape out, you can correct opaques by overpainting, as I said a moment ago.

Because of this special combination of advantages —quick drying, easy correction, wide range of effects, solidity of color, fast or slow buildup as the artist chooses—opaques have always been the most popular medium with illustrators, renderers, and all commercial artists who need a type of paint that's both speedy and versatile. For the same reasons, it's been a favorite medium with mercurial, fast-working painters like Matisse and Picasso: men whose minds teem with ideas, who experiment restlessly, who backtrack and change their pictorial ideas from moment to moment, who need a medium that will respond instantly to their temperament.

Nor do I think I'll insult the medium (or the reader) if I say that these qualities make opaques the easiest material for the beginning painter: a medium that doesn't intimidate you like oil, that doesn't charge off like a bucking bronco and leave the beginner behind, as too often happens with watercolor. Opaques will let you proceed at your own speed. They'll do what you tell them to do, with very little fuss or resistance. They'll let you hesitate, change your mind, make a mistake and correct it without embarrassment.

Whether you're a beginner or a pro, if you haven't met opaque watercolor before, you've found a new friend. Now let's get to work .

Materials and Tools

There's no reason to pretend that I'm objective about my praise for opaque paint. To my mind, it's the best of all possible media, both for commercial and fine art. I do believe that there's hardly an effect that can't be obtained with opaque water-color. The medium spreads easily, covers quickly, and dries fast. It can be applied to any support—paper, canvas, gesso, cardboard, Masonite, even acetate. With opaques, the longest, thinnest line can be pulled; the largest tonal area can be painted evenly; and the thickest impastos, thinnest washes, and greatest possible variety of textures can be obtained. All this and more is easily done with the medium we're about to explore.

Those of you who've had experience with opaques will forgive me while I explain a few facts. Just as there are procedures that will help you take advantage of the different behavior of other paints, so must we explore the unique properties inherent in opaques.

Behavior of Opaques

As I said earlier, the term *opaque* means that the paint is dense enough to cover another layer of paint, even if the first one is darker. Therein lies the medium's greatest virtue: it allows the artist to apply a middle tone over an entire area and then, when dry, to paint lights and darks on it. In opaque painting, forms are modeled—that is, given the illusion of dimension—by applying light and dark tones over a flat tone with a drybrush technique. The two dimensional disc illustrated here was transformed into a three dimensional sphere by painting lights and darks over the flat, middle tone.

The fact that a light tone will cover a dark one is the cornerstone of this whole book. Upon this principle, every demonstration rests and every picture is developed. I want you to absorb this principle until it becomes second nature.

Opaques remain moist and pliant for a long, long time if the cap on the tube is put back with care, or if the lid on the jar is twisted securely into place. If by chance you've re-covered the tubes or jars so tightly that the top won't budge, apply the flame of a match to the cover's rim; the heat will make the cap expand and loosen it up.

Some people find it easier to maintain the pliancy of opaques in jars because paint in jars can be so easily checked and modified. If you find that the contents are getting a bit unyielding, just add water,

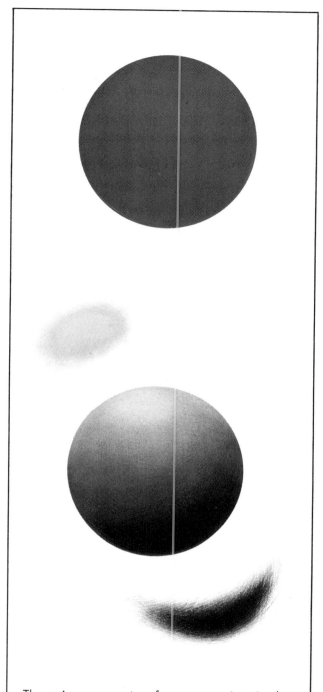

The unique property of opaque paints is that they allow you to cover a dark tone with a lighter one. In opaque painting, forms are modeled by brushing lights and darks over a flat, middle tone. The two dimensional disc (top) was transformed into a three dimensional sphere (bottom) in this way.

remix the paint to a thinner consistency, and recap. This should be done periodically so that the pigment won't reach a hardness beyond dissolubility.

The paint *will* dry on the palette, but the remedy for that problem is just as simple: add water to the dry mixture on the palette or to the mounds in the wells. If, however, you find that a certain brand of grays crumbles and disintegrates into a powder that nothing binds together again, discard it and stay with the product that will retain its malleability.

Colors

There are several well known brands of opaque watercolors, including Permogray, Gamma, Winsor & Newton, Triangle, and Pelikan. They're sold in tubes and jars of various sizes.

Give all these brands a good test and select the one you prefer. You'll find that though the various brands differ little in their chemical makeup, they *do* differ. For example, Gamma grays come in six gradations of tone; Permogray come in only five. On the other hand, Permogray markets a set of "cool" grays (with a tinge of blue) and another of "warm" grays (with a tinge of yellow ochre), while Gamma by Grumbacher is a line of "neutral" grays. All reproduce well when used for commercial work. My own word of caution is that to avoid the risk of tonal inaccuracy in printing, cool and warm grays should *not* be used in the same painting. The reason for this is that the camera tends to photograph a cool gray lighter than it actually is.

Brushes

Before we begin painting, let's look into the materials and tools we're going to use. For we must know which tool does what before we can properly do the exercises that follow. Otherwise we may find ourselves using a tiny zero brush to cover a large area or perhaps trying to paint with opaques on wrinkling tracing paper.

A good array of brushes is invaluable. Begin now to accumulate a selection of pointed sable watercolor brushes. Start with Nos. 3, 4, 5, 6, and 7; the bulk of your work will be done with these sizes. Later you can acquire the smaller ones: 2, 1, 0, and 00 for small, meticulous work; and still later, when you've become proficient enough to tackle the big jobs, Nos. 8, 9, 10, 11, and 12.

Winsor & Newton, Simmons, and Grumbacher

(to name only a few) are good, reputable firms that take pride in their products. Try them all. Select a small sable brush from one manufacturer, a medium one from another, and a larger one from a third. See how each handles, how it feels in your hand; notice whether the stroke is resilient and bouncy, the stock well trimmed to form a perfect point. There will be many other qualities that you'll look for after you've become acquainted with this all-important tool. Eventually, you, too, will gravitate to a particular brand, although I advise you never to settle snugly on any one product to the exclusion of new tools that may come on the market. The artist in you must continue exploring and experimenting throughout your career.

Once you've become familiar with pointed sables, you may go on to bristle brushes. There are three popular types of bristles, each of which lends itself to a different function. Brights—flat, thin brushes with short bristles—are perfect for spreading a film of pigment on the first lay-in. Flats are similar to brights, but thicker and with longer bristles to hold more generous amounts of paint. And last, there's the round bristle brush, upon which some artists rely to paint the first linear indication of their subject. The round bristle is also used for certain textural effects, to scumble or stipple on the finished painting. Try it; you, too, may find it useful—if not actually indispensable.

Flats, both sable and bristle, don't necessarily have to be tested when purchased. But when you buy pointed sables, ask the attendant to let you test them for their spring and stamina and to see that the point is well tapered and evenly centered.

Drawing Boards

Your drawing board can range from a simple 18″ x 24″ pine board that leans against a table or desk as it rests on your lap, to an adjustable drawing table that costs a hundred dollars or more.

You can regulate the angle of your drawing board, according to your ease and comfort, from a completely horizontal to an almost vertical position. You may find that no matter how you position your drawing board, you feel awkward and cramped when you sit down to work. This happens more often than you imagine. The only solution to this problem is to work standing up. I know several artists who wouldn't dream of sitting down to do a job. In this stand-up group is Peter Helck, my own master; in the sit-down group was the late Albert

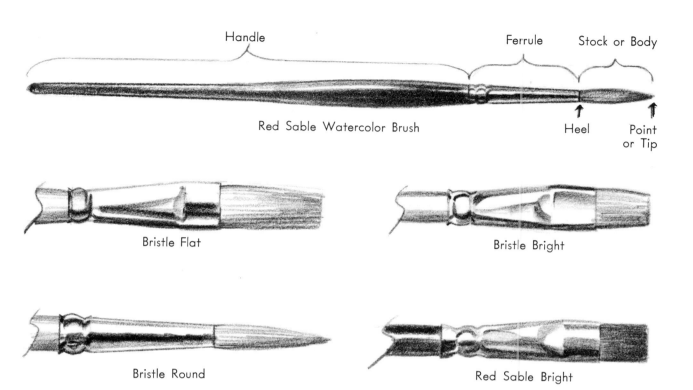

Handle Ferrule Stock or Body

Red Sable Watercolor Brush Heel Point or Tip

Bristle Flat

Bristle Bright

Bristle Round

Red Sable Bright

A good array of brushes is invaluable. Here are the five major types of painting brushes, along with the names of their separate parts. Each type of brush comes in a number of sizes.

This sectioned palette provides separate wells for each tone as well as plenty of space to mix colors to their proper consistency. The paint in each compartment can be kept moist by adding a few drops of water squeezed from a sponge.

Dorne, founder of the Famous Artists Schools in Westport, Connecticut.

After you've settled on a comfortable working position, you may find that resting your hand on a ruler or mahlstick gives you greater freedom and facility in the execution of your painting. Give both methods a good try: the conventional manner of resting your hand on the paper itself, and on the ruler or mahlstick.

Palettes

You can't operate without a palette, be it a white dinner plate, a piece of "milk" glass (plain glass with a white piece of paper under it will work just as well), or a nest of receptacles. Some artists prefer a plastic palette, either circular or rectangular, with sections to separate the paints. Other artists squeeze the colors along the edge of a butcher's tray, then mix them in the middle.

I use two palettes: a sectioned palette, because the pigment can be kept moist by periodically adding a few drops of water with a sponge; and a butcher's tray, because it's large enough to thin the pigment comfortably.

The hard porcelain finish of a butcher's tray is easily scraped clean with a razor blade or a palette knife. If the entire tray is to be washed, fill it with water up to the rim and let it soak overnight. By morning, the dissolved paint can be washed away under a tap.

As you progress and your pictures get larger or more complicated, the use of two trays helps you avoid constant scraping or washing, and also allows you to dedicate one to color, and one to grays.

Papers and Illustration Boards

A large selection of foreign·and domestic papers and illustration boards is available at art supply stores. Don't confine yourself to one brand or one surface until you've tried them all. Strathmore, HD, Crescent, Superior, and Bainbridge are all popular brands. Their surfaces range in texture from hot pressed, which is smooth, to cold pressed, which has a bit more "tooth," to rough. Smooth surfaced paper is usually a logical choice for technical or meticulous rendering of detail. Rougher surfaces invite the broader, looser technique of, say, an editorial illustration.

Follow your own bent. Some artists use only one brand and one surface of illustration board, no matter what type of work is called for. Try, however, to buy the best grades of various surfaces. Don't hamper your work by using second rate materials. This rule applies not only to paper, but to all your tools: brushes, paints, mechanical instruments, lighting equipment, etc.

Always buy a small amount of any item during an experimental stage; but do, by all means, try everything. Never settle on one brand, or one type of article until you've investigated the lot.

Manufacturers constantly meet the requests of professional artists who suggest changes or improvements. So, when a new product comes along, investigate it—it may be far superior to the material you're now using.

Speaking of paper, I must caution you not to use a thin paper for opaque watercolor; it will crinkle, buckle, and cause nothing but frustration. Your support should be no thinner than single weight (sometimes called single thickness) illustration board. This material is simply paper mounted on cardboard about $\frac{1}{16}''$ thick. Single weight paper is sturdy enough for small scale work—say up to 11" x 14". In all cases, but particularly for large scale work, double thick or double weight paper (mounted on sturdy cardboard) is even better. Drawing papers are also available in several weights: 1-ply, 2-ply, etc. These, too, come in varying surfaces—*plate* (very slick and very smooth), and *kid* (with a very slight tooth like an eggshell).

Just one more thing about papers and boards: cheaper kinds yellow much more quickly than better grades. If you're practicing or testing brushes or pigments, use second quality paper; but if the job at hand is an important commission, use nothing but the best so that your work will remain bright and clear for reproduction or exhibition.

Lamps

The finest equipment in the world is useless if your light is poor. Whether you spend all your time painting or whether you do it sporadically, you must have the best light possible. It should be the most constant by day and the correct illumination by night. Place your drawing board next to the largest window (preferably facing north), or get fluorescent lamps that simulate daylight as closely as possible.

One of the favorites is the Dazor lamp for its cool, soft, glareless light. There are, of course, many other makes that may suit you better. You can inspect them at your nearest art supply shop or you can order them by mail.

Tabourets

Now that we have our drawing board, a palette, brushes, and paper, we need a tabouret (or taborette) to store them in. A tabouret is simply a cabinet with a couple of drawers. Its top is roughly 18″ x 30″—just large enough to hold your painting materials. Of course, you can buy larger or smaller tabourets, depending on your personal needs.

If you don't wish to purchase a tabouret, you can make do with any small table that will hold your palette and other materials.

Project 1: Achieving the Right Paint Consistency

The first problem to tackle is the dilution of the paint to its proper consistency. As they come from the manufacturer, opaques are much too thick for easy handling. They must be thinned with water, but not diluted so much that they become transparent, like watercolor, or diluted so little that they lump on the brush. To best cover the paper or another tone, the consistency of your paint should resemble cream soup. Later we shall discuss work done with thin washes and thick impastos, but first we must learn the fundamentals.

Too thin—too much water.

Too thick—not enough water.

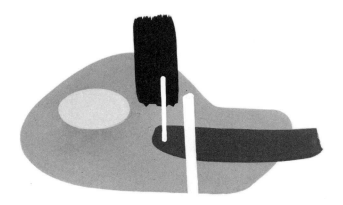

When your paint is thinned to the proper consistency, light tones will cover dark ones, dark tones will cover light ones—smoothly, easily, yet with maximum opacity.

Correct—just enough water.

Project 2: Painting Flat Tones

Now that you can dilute your paint to the proper consistency, you're ready to learn to paint flat tones. To paint a shape in one tone, begin by outlining an area, as the rectangle shown here. Fill it in with quick strokes, spreading the pigment to the border while it's still wet. To get an even tone, avoid going back over a semi-dry spot. Keep the paint moving in all directions in broad strokes, pressing down on the entire stock of the brush rather than picking away lightly in little dabs with its point.

Notice the different results when you load your brush generously and when you charge it lightly.

Try applying the paint horizontally and then, without recharging your brush, stroking it vertically to smooth out possible ridges. Or crisscross the paint as you come down from the top edge. Turn the paper in any direction you wish to facilitate execution. Do anything that's conducive to the result you want. It doesn't matter in the least how you apply the paint—only the result counts.

If, at this stage, the borders of your rectangle aren't straight, don't worry about it. For the present, our main concern is to spread a smooth, even film of paint. We'll practice straight lines later.

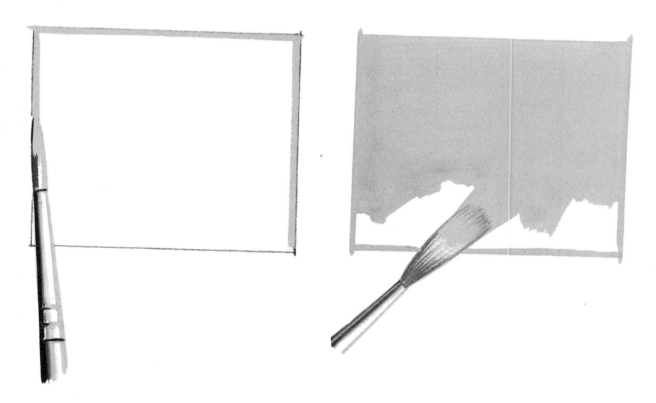

Begin by outlining a rectangle or any other shape.

Fill in the area with quick strokes.

Project 3: Mixing Your Own Values

Value is the lightness or darkness of a tone. The closer a tone is to white, the higher its value; the closer a tone is to black, the lower its value. Every color, therefore, has countless values, ranging from very light to very dark. In a painting, the proper relationship of values to each other is what creates the illusion of depth.

To learn to see and use values, we'll work with black, white, and gray. In this project, you'll find illustrations of six tones of gray, just as they come from the manufacturer. By adding various amounts of white and black to this palette, you can create a value range extensive enough to handle any type of picture.

Practice mixing your own values in the following way. Use a palette knife (or a brush) to mix a middle gray (50% black, 50% white), as indicated in the illustration. To make a 25% gray, mix equal amounts of white and middle gray. To make a 75% gray, mix equal amounts of black and middle gray. Continue in the same way to make as many tones of gray as you wish. Though you're working in monochrome, you'd follow the same procedure of adding white or black to change the value of *any* color. If you changed the value of, say, red by adding white, you'd call the lighter red a *tint*. If you changed the value by adding black, you'd call the darker red a *shade*.

When you work with opaques, always remember that to lighten a value, you add white. Do not try to lighten a value by adding water, as you would do if you were working in transparent watercolor.

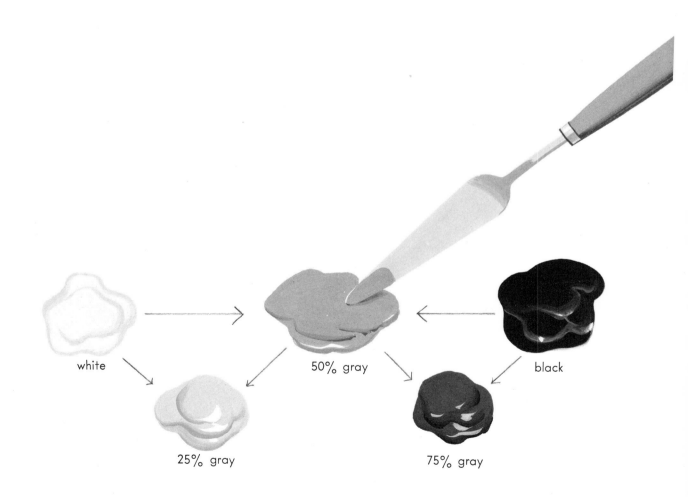

white 50% gray black

25% gray 75% gray

You can mix these tones yourself by adding various amounts of black and white to middle gray.

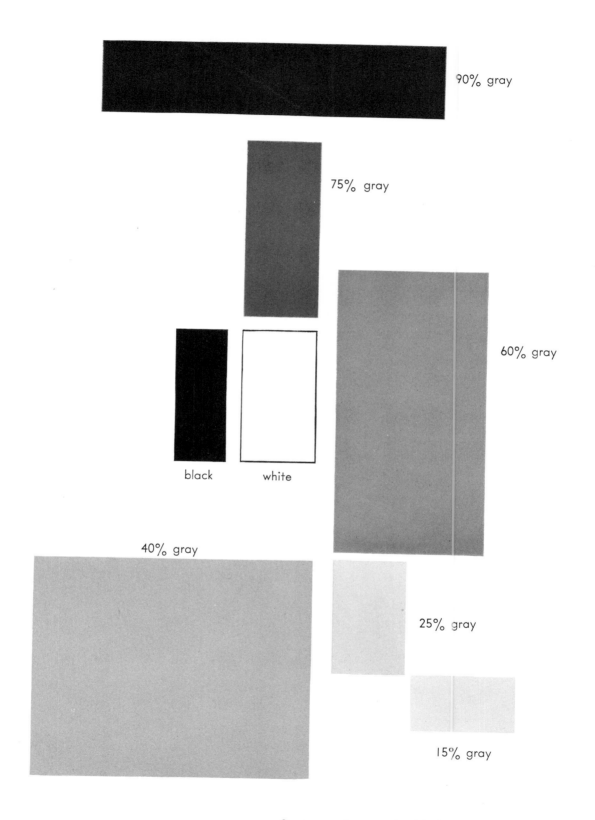

90% gray

75% gray

60% gray

black white

40% gray

25% gray

15% gray

Six tones of gray plus black and white, just as they come from the manufacturer in the tube or jar.

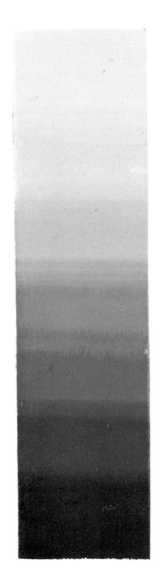

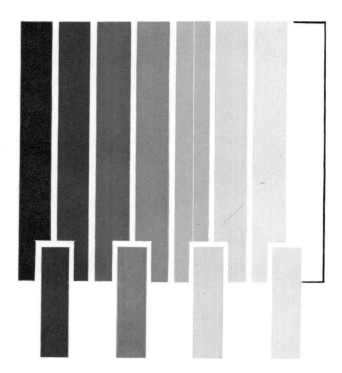

(Left) While we're talking about different tones, let's discuss the value scale. The word "scale" suggests that, like music, a painting can convey a mood by its tonal key. It would be difficult to project a somber, frightening, or dramatic situation in the light tones at the top of the value scale; we need the heavy, gloomy, dark shades at the bottom.

(Right) The intermediate tones placed below the eight basic tones are simply to illustrate that should you want a fuller scale with still closer values, all you have to do is mix equal parts of adjacent tones. Working with a variety of grays makes it easier for you to blend one tone into another because the distinction between them isn't so sharp.

Project 4: Painting Shapes in Various Tones

Let me urge you not to jump ahead and try an exercise here and there as you flip the pages of this book. Master each assignment in sequence. You can placate your impatience in the knowledge that a job well done at each stage will give you the craftsmanship necessary to paint any subject by the end of the book.

Now that you can paint a smooth, evenly toned rectangle in one value and can mix any value you may need, the next step is to put these skills together. The purpose of this exercise will be to make you aware that a painting is an arrangement of shapes of different values.

Begin by sketching lightly in pencil any group of shapes you wish. You may want to combine squares, circles, rectangles, and triangles in the same design; or you may prefer to group variations of a single shape. Whatever you decide, your forms must overlap one another and hold together as a unit (it doesn't matter which shape is on top of which).

Now paint your group of shapes, choosing a different value for each form in the picture. Work in values of gray, as I've done in the illustration on this page. Paint the same design several times, using different values each time. Try different designs. Experiment!

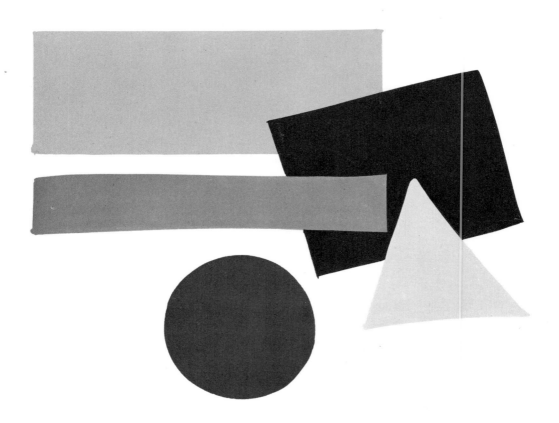

Essentially, all paintings are arrangements of shapes of different values. Here I've created a simple composition from geometric shapes overlapped and painted in various tones of gray.

Project 5: Wet Blending Tones

Now that you can paint any shape in flat tones, let's move on to one of the mysteries of opaque painting —the technique of wet blending to make a graded tone. There are three methods of wet blending.

In the first method (illustrated below, left), you juxtapose two values, then zig-zag your brush horizontally across them to soften the hard edge. Finally, you run a fanned out brush vertically over the zig-zag to smooth out the transition from light to dark. This three step operation must be done while the paint is still wet.

A second approach is to lay any number of values you wish side by side (illustrated below, right). Allow them to dry, and then with a damp—not wet— brush, soften the definite tone separations.

Still another way is to paint a tone across, and while it is still wet, join another to it, and then another to get a smooth gradation of tone like the ground in the illustration on the facing page.

Try all three techniques. Since they produce virtually the same results, adopt the one you prefer. Whichever you select, you'll have to practice to learn how much pressure to apply to the brush, how much paint to load on the brush, and even how many brushes you need for each method of wet blending.

You may, if you wish, use this wet-in-wet blending in your finished work. Many well known artists have done so. Personally, I relegate it to *underpainting* because it's never exact enough for me.

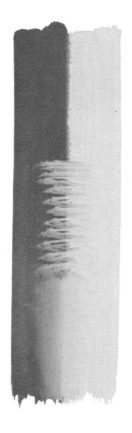

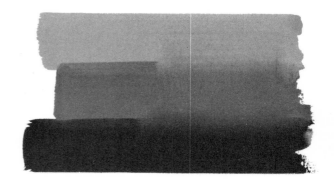

One method of wet blending is to juxtapose two values, zig-zag a brush across them to soften the edge while the paint is still wet, and then run a brush over it to smooth out the transition from light to dark.

Another technique is to lay a number of values side by side, let them dry, and then soften the tonal separations between them by going over these values with a slightly damp brush.

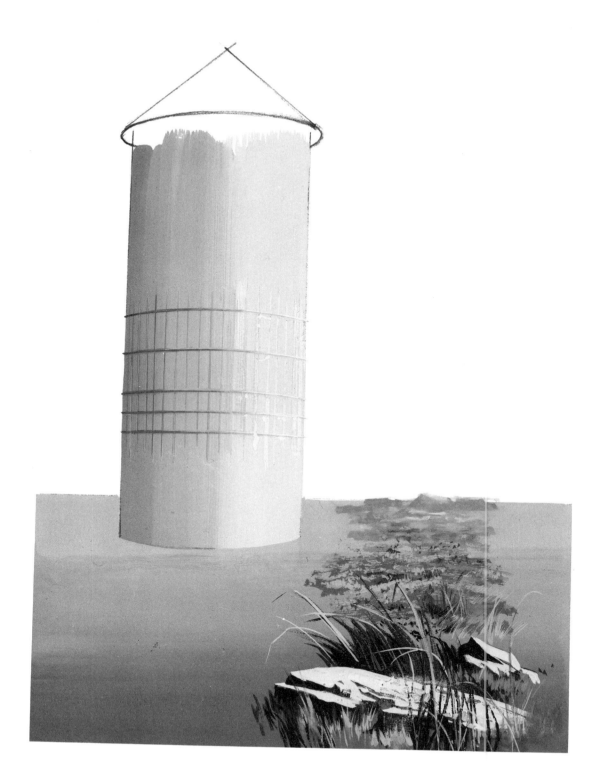

Two wet blending techniques have been applied in this picture. The zig-zag method described and illustrated on the facing page serves as an underpainting for the silo, now ready to receive whatever detail you want to add on top. The side-by-side method has been used to create depth and space in the ground area. Over these graded tones, you can introduce whatever textures or vegetation your picture requires.

Project 6: Painting Over a Graded Tone

Consider the tremendous job it would be to paint on an untouched white ground all the different values that are needed to suggest a plot of grass. Now consider how much simpler the task becomes if we try to achieve the same results by painting over a graded tone. Not only is the job quicker and easier when you paint lighter and darker strokes over a toned background, but your rendering acquires a directness and spontaneity that couldn't otherwise be achieved.

Try it. Using a wet blending technique, begin by covering your paper with a graded tone that starts at the bottom in a middle gray value and lightens subtly as it works its way up. When this toned ground has dried, paint a field of low grass by applying light and dark strokes on top of it. Begin with short, vertical strokes in the foreground. Make the strokes diminish in length and lighten in value as they recede into the middle distance. As they approach the horizon line, the strokes should become increasingly horizontal and broad. To paint taller grass, use longer strokes in the foreground. As you work toward the distance, decrease the length of your strokes, but keep them more or less vertical.

Notice how simple it becomes to paint the many values in a field of grass when you work over a graded tone. All you need to do is apply light and dark strokes on top of it.

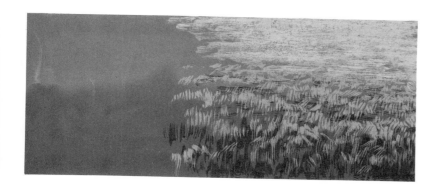

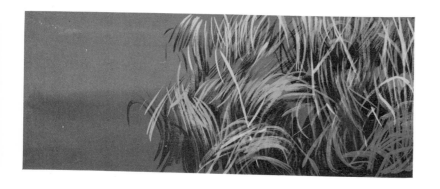

25

Project 7: Painting a Tree in Values of Gray

In this project, we'll be learning two skills: how to transpose nature's colors into their corresponding values of black, white, and gray; and how to proceed, step-by-step, to paint a picture. The procedures shown in this project will be followed throughout the book.

If we take a photograph in black and white, all the objects—regardless of their true colors—will show up in various tones of gray, ranging from off-black to off-white. As we paint in black and white, we transpose nature's colors into their corresponding white, black, and gray tones. The closer we can approximate these colors in their equivalent values of gray, the more convincing will be the tonal scheme of our picture. A beige drapery, a lemon, lettuce, blond hair, the foliage on some trees, for example, will all be painted a light gray. The color red will come off as a medium gray, and dark brown will show up black.

Let's apply this concept to a practical painting problem. Begin by making a pencil sketch of the tree you intend to paint. In the drawing, work the same size as you envision your final painting. The purpose of the drawing is to give you the opportunity to work out every problem in pencil before you tackle the final painting. It's much easier to raise or lower a tone, modify a shape, even erase it entirely, if your tool is a pencil. Work over your drawing until you're completely satisfied that it's correct. Pay particular attention to values: where do the middle tones fall? where are the light and shadow areas?

When you've finished, turn your drawing over and lay it on a flat, clean surface. Take a soft pencil and blacken the entire reverse side of your sketch by rubbing the pencil over it. Now tack the drawing to your illustration board, with the blackened side resting against the face of the board, and trace over the main shapes of the drawing with a hard pencil. Remove the pencil drawing from the illustration board and place it close by for reference.

Study the values in your pencil drawing and try to match them in *dry* opaque paint. Some grays change very little from wet to dry, but others—especially the lighter values—darken considerably as they dry. That's why it's always wise to select the value you want from dry, rather than wet, opaques.

Once you've selected your paint, the next step is to apply it in flat tones over your outline on the illustration board, matching the tones in your pencil drawing. I've selected three flat middle tones and I've used them to make a simple lay-in of flat shapes. At this stage, the light and shadow areas on the trunk and foliage are ignored.

The final step is to render the light and dark detail on top of the flat middle tones. This is accomplished with a very light gray and a black. In the foliage, the lightest values were applied over the lighter middle tones, and the darkest values were applied over the darker middle tones. Light and shadow areas have now been applied to the trunk, which was originally rendered in a uniform middle gray.

After you've finished painting the tree, look around and transpose the values of the wall, the chair, and the other articles in your studio to their corresponding grays. Paint them following the procedures you've used in this project. Remember that your job as an artist is not to parrot or copy either my work, a photograph, or even nature. Your task is to select and modify your reference material to suit your particular picture. As you go along, you'll find yourself distorting a shape, intensifying a tone, exaggerating a texture to strengthen your pictorial statement.

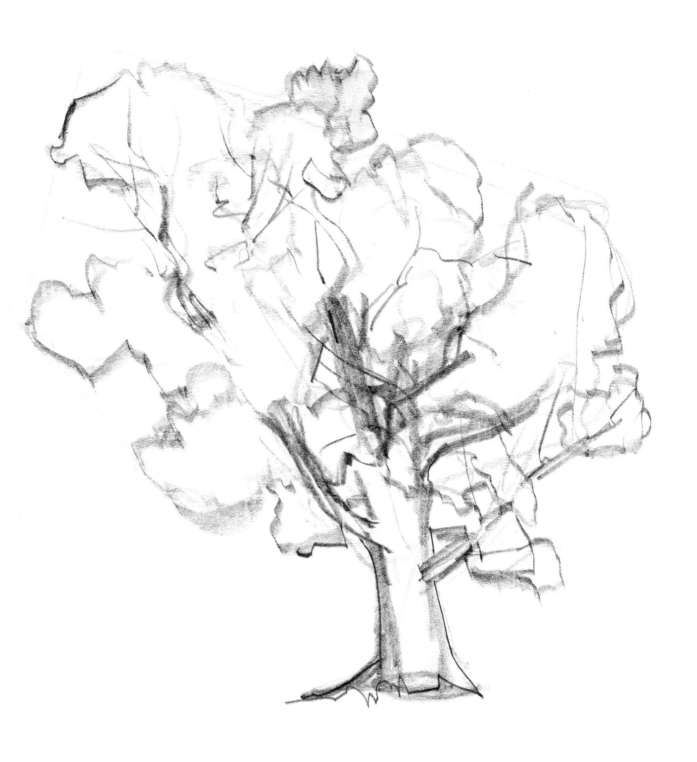

First sketch your subject in pencil, the same size as you envision your final painting. Pay close attention to the values. Where do the middle tones, the lights, and the darks fall?

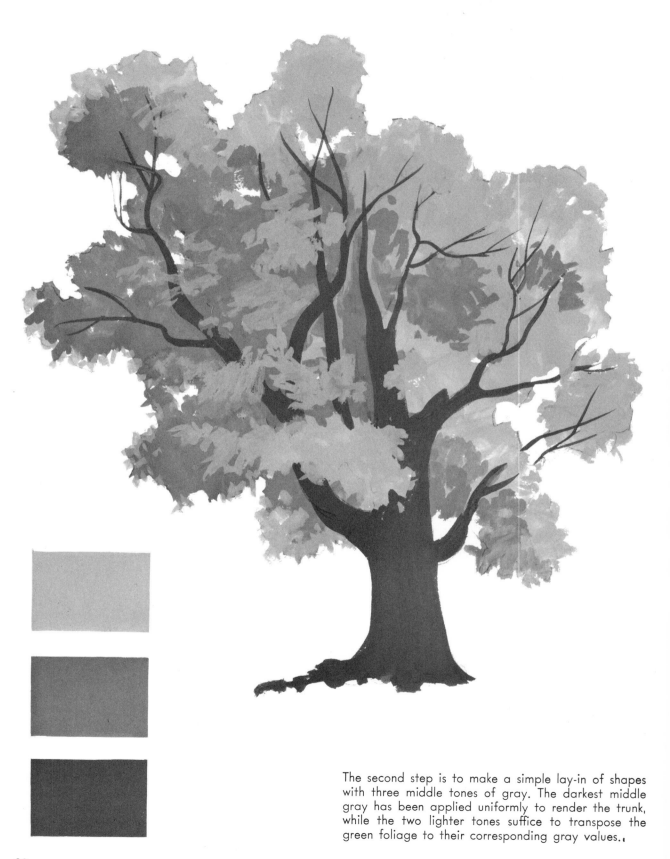

The second step is to make a simple lay-in of shapes with three middle tones of gray. The darkest middle gray has been applied uniformly to render the trunk, while the two lighter tones suffice to transpose the green foliage to their corresponding gray values.

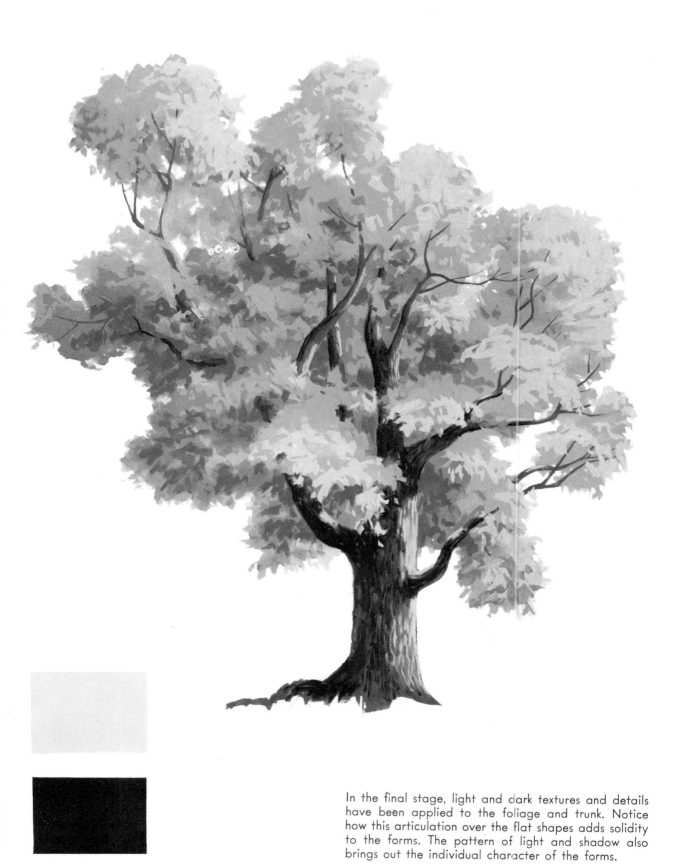

In the final stage, light and dark textures and details have been applied to the foliage and trunk. Notice how this articulation over the flat shapes adds solidity to the forms. The pattern of light and shadow also brings out the individual character of the forms.

Project 8: The Technique of Drybrushing

You already know that opaques can be blended when wet (Project 5) to make a graded tone that's perfectly suited for use as an underpainting. To make a rigidly controlled blended area, however, you'll want to use the drybrush technique. ("Drybrush" is actually a misnomer, since the brush isn't really dry; the term was probably coined because the *result* dries almost instantly.)

To make a controlled graded tone by the drybrush method, follow this procedure. Begin with a flat shape (I've chosen a rectangle), match the value of the gray on the facing page, and paint your shape in a flat tone, the same size as illustrated.

When your flat tone is dry, charge your brush with thin paint and fan the brush as shown by pressing the stock on scrap paper. Apply each stroke lightly, with a sweeping motion, keeping the brush fanned or feathered as you work (on blank scrap paper until you get the feel of it). The strokes can be swept in any direction. Find out which feels best to you and stay with it. Try the one demonstrated here—from southwest to northeast, as it were—and if you feel most comfortable stroking in these directions, just invert your paper to change the direction of your strokes.

When you've gotten the knack, match the four tones that you see in the circles on the facing page: two light grays, a dark gray, and a black. You'll use these to drybrush graded tones over the flat rectangle.

What I'm going to tell you now is very important. Mark it well. Since the area you're going to drybrush is already completely covered with paint, the opaque colors you'll now apply must be *much thinner* than the underpainting so that the paint layers don't pile up and become unwieldy.

Working from dark to light, drybrush the dark gray and black to serve as the shadow below, and the lighter grays to serve as the light areas at the top of the rectangle. Each time your brush begins to regain its original pointed shape, recharge it with thin paint and again press the stock on scrap paper (blotting paper is even better) to fan it and to discharge excess pigment.

This is a very important exercise, but don't be timid or apprehensive. Relax. Let yourself go. Dilute more paint and sweep away. Loosen up your wrist and your entire arm. Don't grip the brush, but hold it lightly at the angle illustrated. Don't be concerned if you sweep beyond the borders of the rectangle. Notice that I went beyond them (left side), and then trimmed back with white to regain the edge (right side). I intentionally left this procedure unfinished so that you could see how easily a shape can be trimmed back with a background value or with an adjoining tone.

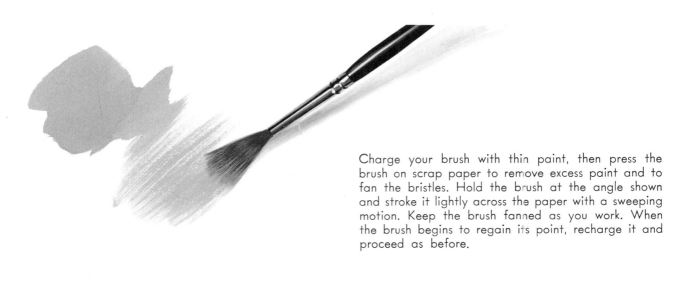

Charge your brush with thin paint, then press the brush on scrap paper to remove excess paint and to fan the bristles. Hold the brush at the angle shown and stroke it lightly across the paper with a sweeping motion. Keep the brush fanned as you work. When the brush begins to regain its point, recharge it and proceed as before.

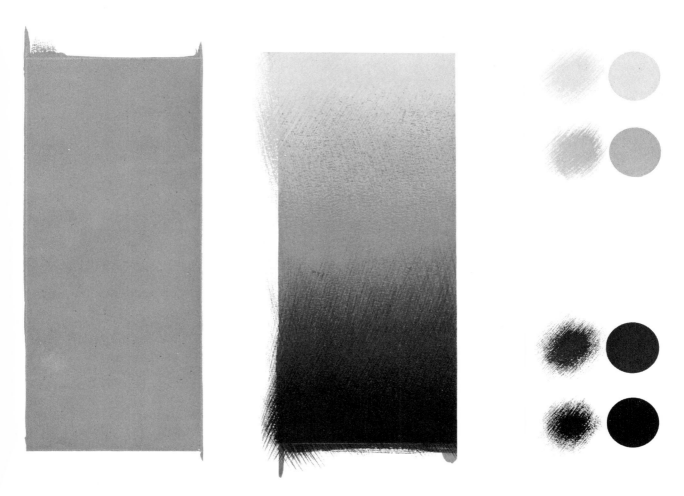

This very controlled graded tone (center) was applied over the flat gray rectangle (left) with a drybrush technique, using the four tones shown at the right.

Project 9: Drawing and Painting Rocks

We've already learned to paint trees and grass. Now let's add another item to our landscape vocabulary —rocks. Though rocks are invariably angular, rough, and massive, you'd be amazed how often they're painted as though they were puffs of cotton. Whatever you paint—a mountain, a mosquito, a teacup, or a tugboat—make sure to preserve its character. Search out its essential qualities and go after them hammer and tongs. In pursuing the essence of an object, an artist will overstate a shape, exaggerate a texture, and stress a line to emphasize his intent.

In the pencil drawing below, note the well defined configurations, the sharp transitions between the planes facing the light and those in the shadow. This harsh modeling, in conjunction with the added textural effects, conveys the character of the rocks. To accentuate and contrast with the rigidity and asperity of the main subject, I've introduced patches of grass, a pliant and delicate element.

You can compose your pencil sketch directly from nature, from photographs, or from a combination of both sources. Whichever you opt for, your purpose is the same—to experiment, to solve all the problems in your picture in pencil before you begin to work in opaques. You must clearly establish the source and angle of your light, and distribute your shadows accordingly. You must finalize your composition: alter a shape, move a rock, introduce a patch of grass, add clouds where none exist. You can bend a tree, make it taller or shorter, or even eliminate it if it disturbs your composition.

All this arranging of shapes and lines and textures is a purely personal matter. The essential point is that it must be done now, before you begin to paint. Once you pick up your brush, the only problem you should face is the application of the paint itself.

When you've completed your drawing, blacken the reverse side with soft pencil, tack it to your illustration board, and trace the outline of the entire mass of rocks. Remove the pencil drawing and place it close by for reference. Now paint the outline of your rock formation in a flat, even, middle gray. When the paint has dried, take your pencil and trace over this middle tone the main lines established in your sketch. Then, matching the tones in your drawing with dry opaque, paint in the darkest darks and work your way up to the lightest lights. Define the edges sharply; do the grass last.

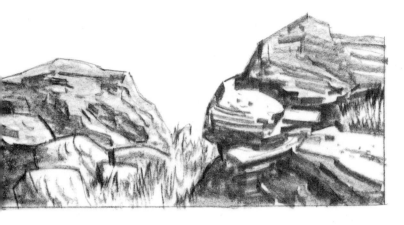

Work out all your problems in the pencil drawing, paying particular attention to composition, texture, tone.

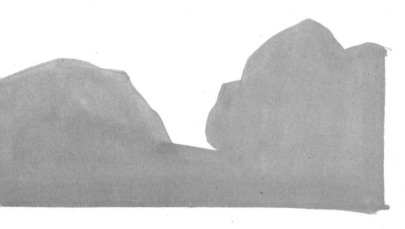

Trace the outline of the rock mass to illustration board and fill it in with flat, middle gray.

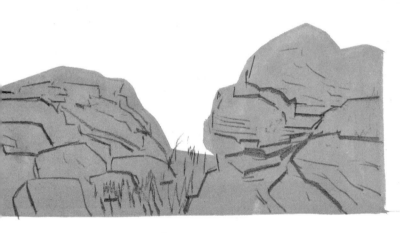

Trace the main lines established in your drawing over this middle tone.

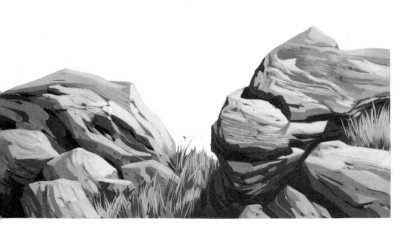

Paint in the darkest darks and work your way up to the lightest lights. Leave the grass until last.

Project 10: Painting Water

Let's try three more pictures now, putting to use the different techniques we've learned so far to paint various kinds of water—still water, rippled water, and the sea. You may be pleasantly surprised to discover that although you haven't tried to paint these subjects before, you are now technically equipped to handle them with ease.

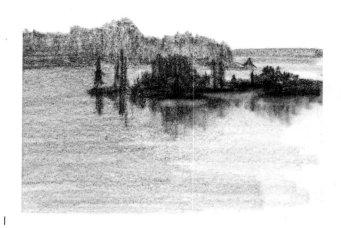

1

2

3

To paint still water: (1) Prepare your pencil drawing in the usual way. (2) Matching the values in the pencil sketch, lay in your flat tones. (3) Use your newly learned technique of drybrushing to suggest still water. Brush in the lights first; then place the darks to render the reflections of the trees.

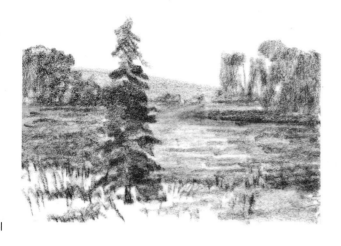

1

1

2

2

3

3

To paint rippled water: (1) Sketch your subject in pencil as before. (2) Lay in the big shapes in flat tones corresponding to your sketch. (3) Render the dark and light articulation on top of the lay-in. Use short, delicate, horizontal strokes to suggest the ripples of the water. Gradually smooth out these strokes as you work toward the horizon. Trace the evergreen tree over the completed picture and render it in the darkest values to give the picture depth.

To paint the sea: (1) Again prepare your pencil drawing. (2) Transfer the outline of the major shapes to illustration board; use a horizontal wet-in-wet technique to make a graded tone for the water. Lay in the rock formation in flat tones corresponding to the values in your drawing. (3) For the foam and waves, work over the graded tone in white, scribbling and scrubbing in the foreground, using thinner paint and lighter strokes as you work toward the far distance. Trim back your borders with white.

Project 11: Using Common Sense

Did you notice, in Project 10, that I painted in the evergreen tree *last,* after I'd completed the rest of the picture? That reminded me to bring up something a student usually discards when he reaches for a brush—common sense. Yes, just plain, every-day common sense. An individual may use common sense in everything he does, but the moment he's confronted with a painting problem, he throws it to the four winds.

Take, for example, the chap who paints a tree, with its multitudinous details, on a bare illustration board, *and then* paints the sky around every twig, branch, and mass of foliage. Or look at the fellow who carefully renders a fence in the foreground, and must then work around and between every post and rail to paint the scene behind it.

After your pencil drawing is prepared, you should always ask yourself such practical questions as, "How much of the drawing need I trace for my lay-in? Should I transfer the entire drawing onto the bare illustration board, or should I paint a portion of the board beforehand? Should the whole picture area be given a thin coat of light or medium gray before I trace the drawing? Would it be better to use the paper itself for the whites, or should I paint them later over a gray ground?"

To questions like these, the answer is, *use common sense.* A sort of first-things-first attitude will keep you from the frustrations of thoughtless muddling through. A good safeguard is to stop whatever you may be doing the moment it becomes awkward and difficult. Take time to analyze the problem; chances are the answer that comes to you will be so simple that you'll wonder how it could have escaped you before.

One way to avoid trouble is to begin painting from the bottom up (this applies to the lay-in as well as to the finished painting). By "bottom up" I don't mean that you start at the lower half of the paper and work your way to the upper half, but rather, that you paint in layers. Let me demonstrate. In the three step-by-step illustrations, I first painted the big shapes—the river, the sky, the background hill. Next, I placed the forms "coming up" on top of the first shapes—the background tree, the bank of the river, the middle distance tree, and the foreground patch of earth. Finally, I rendered the white posts on top of everything.

The examples on the facing page offer two approaches that can be applied to similar problems you'll encounter in the future, as well as to the particular elements depicted here. The first example illustrates that to paint branches against the sky, the logical and reasonable thing to do is to paint the background first, the tree on top. You'd use the same approach to paint a white ladder against a gray wall.

Now suppose that your elements include large cumulus clouds on a graded sky. To paint the entire sky first, and then lay in the clouds on top would be courting a messy job. The big white strokes might get too thick. If you thinned your paint to avoid this problem, your strokes would begin to pick up the underlying paint. You could spray the sky first with fixative to eliminate this possibility, but then you'd lose the light, fluffy character of the clouds. To my way of thinking, the best solution is to use the paper itself for large white areas—particularly when some modeling is to be done on them, as in the clouds I've painted here.

 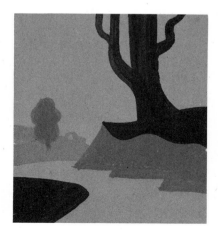 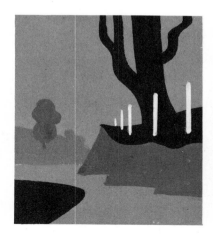

To paint from the "bottom up", lay in the big shapes first (left). Next, place the smaller forms which impose themselves over the big shapes (center). Last, add the topmost forms or details (right).

Paint the sky first.

Then render the branch over this ground.

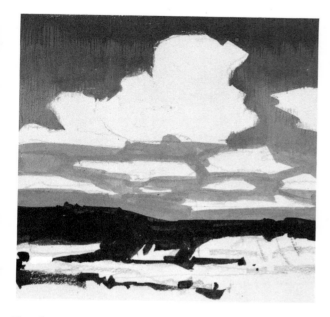

The sky is gradated first, leaving untouched areas for the clouds.

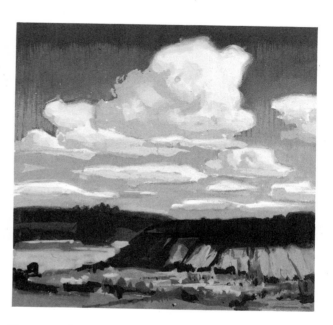

The untouched areas are now modeled to give dimension to the clouds.

Project 12: Experimenting with Unconventional Tools

Congratulations on the knowledge and skill you've acquired in this short time. If you've mastered the previous exercises consecutively and thoroughly, the fundamental principles and basic techniques of opaque painting should be second nature to you. Now you're ready to begin to experiment with more daring tools and techniques.

Those of us who began investigating the potential of opaque watercolor had to grope our way—without benefit of instruction and sometimes for years —to develop the techniques you'll be learning on these pages. My good friend Peter Helck is one of many artists who've experimented with unconventional tools to achieve the unique and exciting effects you're about to try out.

As you embark on these experiments, try to guard against being overwhelmed by novelty for novelty's sake. Have fun, but remember that the goal of technical facility is to free you from mechanical concerns so that you can concentrate more fully on the aesthetics of your painting. The larger the painting vocabulary at your disposal, the greater will be your range of expression. So assemble the off-beat tools suggested, and get started!

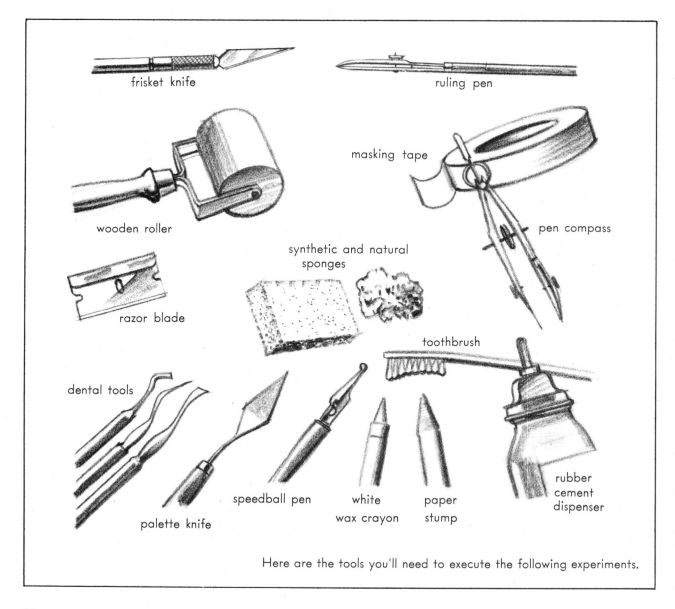

frisket knife

ruling pen

masking tape

wooden roller

pen compass

synthetic and natural sponges

razor blade

toothbrush

dental tools

speedball pen

white wax crayon

paper stump

rubber cement dispenser

palette knife

Here are the tools you'll need to execute the following experiments.

Paint a rectangular shape. While it's still wet, scratch it with a razor blade. The wider the angle of the blade to the paper, the thinner the line will be. Try any tool that will scratch. On your next visit, ask your dentist for some dental tools he no longer uses—they're marvelous for this sort of work.

Paint a rectangle and frame it with strips of masking tape. Cut a slightly larger rectangular opening in the center of a large sheet of paper. Tape this "mat" over the painted rectangle to protect the illustration board from paint spatter. Charge a toothbrush with thin opaque. Right over the opening, scrape the bristles against the edge of a cardboard to create this spatter effect.

With a palette knife apply an impasto of white thick enough to make ridges and protuberances. Let the impasto dry thoroughly and then paint over it in gray. When dry, scrape the surface with a razor blade to reveal the white ridges.

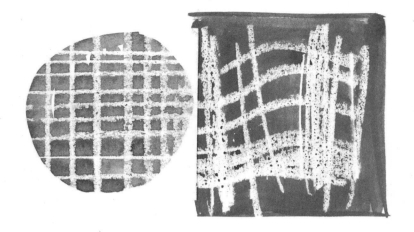

With a white wax crayon draw any pattern you want on illustration board. Then paint any shape you wish over it with opaque. The paint will cover the board, but will not take over the wax of the crayon. Both these illustrations were done with this technique.

Paint an area on a wooden shingle. While the paint is still wet, place a sheet of thin paper over it. Run a roller over the paper to get the impression of the wood grain.

Prepare two puddles of gray paint on your tray, one light, one dark. Run the roller over one puddle and roll the paint on the paper or board. As you apply the paint, tip the roller, run it flat, push and pull, or just push to achieve the effect you want. Wipe the roller; repeat with the other gray.

May we have your comments on
PAINTING IN OPAQUE WATERCOLOR (PBK)
by Rudy de Reyna

WE HOPE THAT YOU HAVE ENJOYED THIS BOOK AND THAT IT WILL OCCUPY A PROUD PLACE IN YOUR LIBRARY. WE WILL BE MOST GRATEFUL IF YOU WILL FILL OUT AND MAIL THIS CARD TO US.

Your comments:

How did this book come to your attention?

Bought at: _____ Gift: _____

Your business or profession: _____

Would you care to receive a catalog of our new publications?

☐ Yes ☐ No

Name _____

Address _____

City _____ State _____ Zip Code _____

FIRST CLASS
Permit No. 46048
NEW YORK, N.Y.

BUSINESS REPLY MAIL

NO POSTAGE STAMP NECESSARY IF MAILED IN THE UNITED STATES

Postage will be paid by

Watson-Guptill Publications
1515 Broadway
New York, New York 10036

Dilute a gray on the tray and spread it into a wide puddle. Press a synthetic sponge into the paint and tap the sponge on the illustration board. The effect you get will depend on the fineness or coarseness of the sponge, on the consistency of the pigment, and on the texture of the paper itself.

Follow the same procedure as above but use a natural sponge. Next time you're at a market or a pharmacy, search for a sponge with varied porosity so that you can obtain fine, as well as coarse, textures.

Frame the area with masking tape. Crinkle a piece of tissue paper into a ball and search for the side with the most interesting twists and corrugations. Press this side into a puddle of paint and then tap it against the illustration board, turning and twisting as you cover the area. When dry, remove the tape.

Roll the entire end of a paper stump in a puddle of gray; now hold the stump between your thumb and next two fingers, but grasp it under your palm, and not on the side of your hand like a pencil. This method gives you greater freedom to change from its tip to its side for the lively line and spontaneous strokes shown here.

With your palette knife (preferably the trowel type rather than the straight), scoop up some paint and spread it on the board. The texture of the paper itself—rough or smooth—and the consistency of the paint—thick, medium, or thin—will determine the result of this experiment.

Again tape the area to be painted. Using either a stick or the brush attached to the cap of your rubber cement dispenser, drip rubber cement on the bare illustration board. You can make whatever configurations you want, but make sure that the cement is not too thin or it will spread beyond the desired pattern. When the rubber cement is completely dry, paint a tone, either flat or gradated, over the entire shape. Let dry and then remove the cement with a "pick-up" (a crepe rubber eraser that removes dry rubber cement).

Dip a ruling pen directly into diluted opaque or load the pen from a charged brush. Hold the ruling pen like a pencil to make the thin lines, but shift to the "under the palm" manner to decrease the angle that will give you the broad strokes. Practice will show you how thin the paint should be to assure easy flowing.

Load the pen compass with paint in the same way as you loaded the ruling pen. Be careful not to screw the pen blades so tightly that the pigment will not flow. Adjust the opening in the pen according to the consistency of the paint. If your paint is too thin it will blob as the pen touches the paper.

Speedball pens come in various nibs: round, flat, square, and oval. They can be dipped directly in this opaque, or loaded with a pointed brush. It's a terrific tool for making uniform dots and for either "quiet" or "nervous" lines.

Project 13: Frisketing and Other Imaginative Techniques

If you enjoyed the exercises you just did, you can go on experimenting if you wish. Try, for example, an old fashioned quill pen or a reed pen for a vivacious calligraphic line. Find a piece of wire screen and paint through it with a stiff brush for a scintillating checkered effect. Or, get a pipe cleaner, dip one end in pigment, and rotate it on the paper. Perhaps there's a piece of steel wool in the house; make a wad, press it on a puddle of pigment, and tap it on your paper as you did with the sponges.

The possibilities for unusual effects are endless. From now on, be on the alert for anything that may lend itself for use as a tool. If you find yourself stippling with a Turkish towel, or rolling your paint with hair rollers, or scratching paint surfaces with your fingernail, that's as it should be. Make it a point to devote some spare time to investigating new techniques or to combining old ones in new ways. File away these discoveries for future use.

I'd like to emphasize a point. No matter how terrific an individual effect may be, don't let it be so blatant that it cries out for attention and detracts from your picture as a whole. Let the results of unconventional tools be incorporated into your work—but always as an aid to the over-all effect.

Let's apply some of the experiments we've done so that you'll see how they enhance certain graphic designs and illustrations.

To execute the pot-bellied stove on the facing page, I used a technique called *frisketing*. Here's the pro-cedure. Execute your drawing in line on a sheet of thin paper and leave generous margins. Tape the drawing to the top edge of your illustration board. Now flip up the drawing and apply rubber cement to its reverse side and to the general area it will cover on the illustration board. Flip back the drawing so that the two cemented surfaces (facing paper and board) adhere to each other and smooth the paper with the edge of a triangle or ruler to eliminate wrinkles or bubbles. Let the cement dry for twenty or thirty minutes.

Take a frisket knife and cut into the pencil lines of your drawing, including the vents and the ash receptacle. Now lift off the entire cut drawing by inserting the point of the frisket knife at any of its corners. Obviously some parts of the sheet will stick to the board. Clean off the dried rubber cement left on the bare board with your "pick-up" eraser. Spread a puddle of dark gray opaque, charge a wooden roller with it, and roll it over the cut-out on your illustration board. When the paint is completely dry, remove the rest of the facing paper and clean off any remaining bits of rubber cement. Use a brush to touch up any edge or detail that needs further articulation.

This multi-step procedure shall be referred to from now on merely as "frisketing a drawing." Frisketing can be used on subjects that call for this kind of textural treatment. Just be sure that your results are compatible with your subject. Now let's go on to other designs.

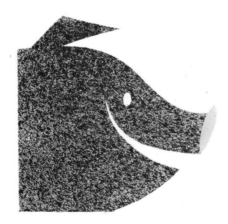

Frisket the pig in the center of extra large, thin paper to protect the board. Spatter the paint with a toothbrush. When dry, paint the eye and snout with a brush.

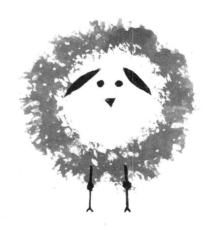

Dip the corner of a synthetic sponge in paint and tap the circle. Let dry and draw in the face and legs of the sheep with a brush.

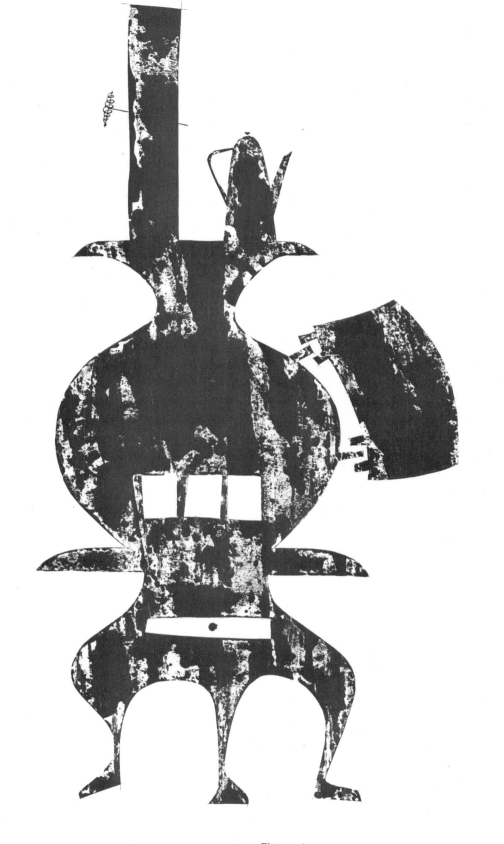

This stylized pot-bellied stove was executed by frisketing a drawing on illustration board. Paint was applied over the frisketed area with a wooden roller.

Frisket the skyline. Dip a wad of tissue in a puddle of pigment and tap from the top downwards. Add the waves and boat with a brush.

Tape the rectangle with masking tape. Draw the musical notes with white wax crayon. Blend the gray and black wavy pattern over the entire area, wet-in-wet. Add whatever lettering suits your purpose. Remove the masking tape.

Transfer the drawing to illustration board. Load a compass with gray and outline the entire sun and the gray edge of the children. Rinse off the gray from the compass, wipe, and load with black to outline the rest of the circle of the faces. With a brush, fill in the gray and black areas and add details.

Take a wood impression from a shingle (see Project 12) and cut out the shield with a razor blade or frisket knife. Glue the shield to illustration board with rubber cement. Letter the words shown or any others you wish.

Tape the drawing to the top edge of your illustration board. Trace only the gown, then flip back the drawing. Rubber cement a thin sheet of paper on the traced area and frisket it. Clean off the dried cement from the opening and drip a pattern with fresh rubber cement. When dry, gradate the tone with a brush. Again allow to dry, and then remove the rubber cement with "pick-up"; lift off the remaining tissue, and remove rubber cement. Flip the drawing back in place, trace the rest of it, and render the hair and folds of the gown with a stump. Finish the rest with a brush.

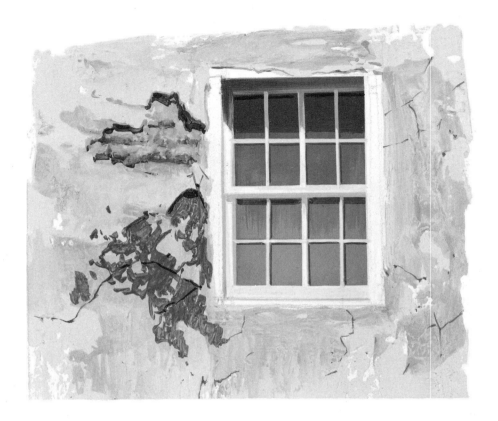

These two paintings demonstrate that off-beat techniques apply equally to graphic design and to realistic illustration. For the almost photographic wall, I used a palette knife to build up the impasto underpainting. With a brush, I then accentuated the resulting ridges and cracks left by the knife. The window, the peeling plaster, and the bricks were rendered in the conventional manner.

This abstraction was done with an ordinary speedball pen over a panel painted gray.

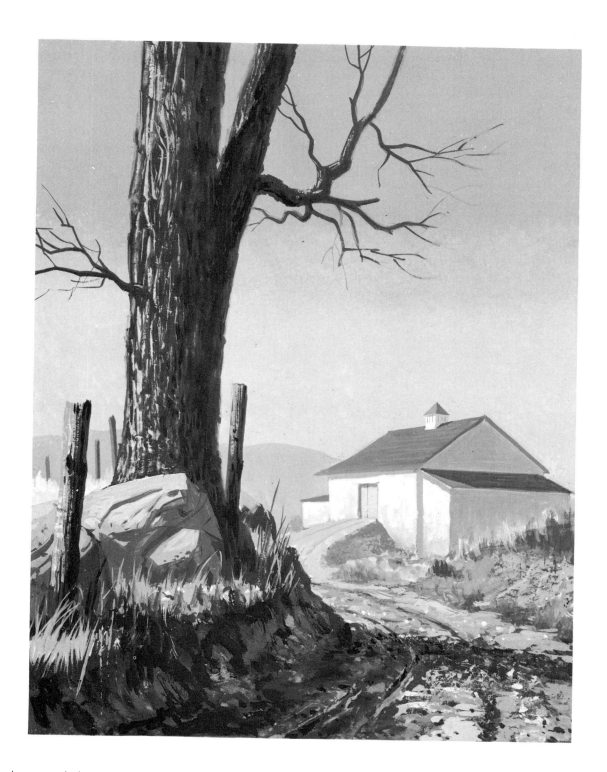

Here's a good demonstration of the adaptability of unconventional tools to render a realistic picture. The sky was applied and blended with sponges. Tree and posts were painted with brushes, then scratched with dental tools. The rocks and road were built up into a thick impasto (same value as the upper sky) with a palette knife. For textural effect, sponges and crinkled tissue were tapped over it. Hill, barn, grass, and the detail on the rocks were painted with brushes. A few damp brush rubbings pulled the picture together.

Project 14: Painting the Human Head

If your goal is commercial art, you'll find that the male or female head is a constantly recurring commission. The target of every product or service is people, and the face has the power to express every human emotion. Since art directors like to concentrate their message into an arresting bull's-eye, what could be wiser than focusing on the human head?

So instead of just looking at heads, begin to really see them with an artist's eye. You'll discover certain faces ready made to "sell," for instance, gasoline; others inspire confidence in the insurance, banking, or medical services they endorse; still others personify "the chef," "the butler," "the pilot," and even "the artist." These are stereotypes, of course, which totally accept the popular concept of what certain people should look like.

If you're a painter, you're likely to be sensitive to the expressions on a face and what they signify. You'll notice pathos, nostalgia, resignation, perhaps complete disillusionment. On the other hand, you might be struck by an expression of quiet wisdom, intellectual sparkle, or eager curiosity.

No matter what your purpose in studying people, resolve now to become more responsive to their faces. Learn to "read" them and to detect in them the subtlest shade of emotion. Then, through the medium of your art, learn to enhance the reality of the face you see. To preserve its character, you'll paint a rugged face in a low rather than high key. By the same token, a young girl in light and high spirits will call for the lighter part of the tonal scale, with only enough darks to serve as a foil.

These and a thousand other bits of knowledge enter into the making of every picture. However you study—in life class with a teacher, or in the privacy of your studio with books—you must accumulate knowledge piece by piece and file it away until you need the information. As you work, you'll experience flashes of memory—things you read or heard long ago. They may concern the structure of the human figure, the tilt of a head, the gesture of a hand; or you may suddenly recall some point about perspective, textural distribution, or tonal scheme.

These and countless other considerations will assail you as you begin your first preparatory sketch. Let them flood your mind. Turn them over, inspect them, reject them, and finally select what's essential.

Before you strike out on your own, work with me, first on a male, and then a female head. I suggest you do all these exercises the same size as they appear in the book. However, if you feel more comfortable working on a larger scale, by all means do so.

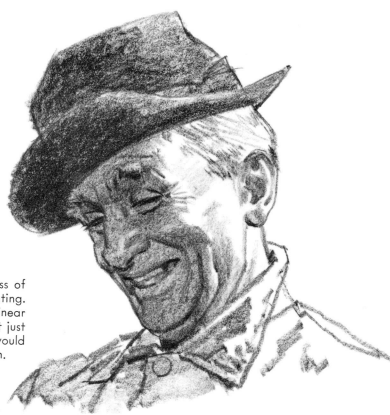

In this pencil drawing, I've stressed the ruggedness of this face by the use of strongly contrasting lighting. Notice the textural qualities of the hat and the linear treatment of the shirt. The tilt of the head did not just happen accidentally. A formal, vertical pose would have stifled the humor and animation of the man.

Once you're satisfied with your pencil drawing (or charcoal, if you prefer), pick out the big shapes and trace them onto your illustration board. If your big shapes are correct, the smaller ones will take care of themselves. Here, the three main shapes are quite obvious: the dark hat, the side of the head receiving light, and the face itself, in shadow.

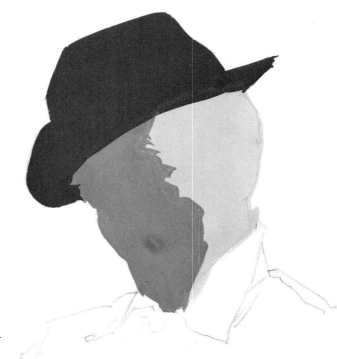

Apply the flat tones over the three main areas transferred from the working drawing.

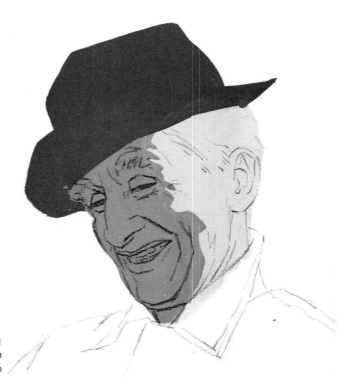

When this underpainting has dried, flip the drawing back over the painted areas and now transfer the principal details only. If they come off a bit weak, go over them with an HB pencil.

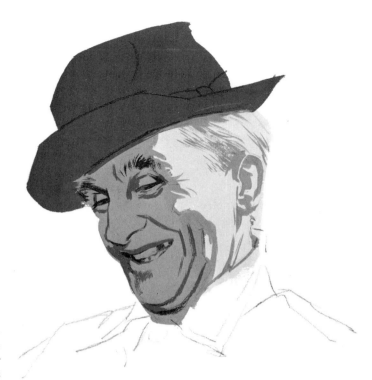

To further reinforce the principal details, paint over your tracing like this so they won't get lost when you begin modeling. You can then feel free to sweep your brush partly over the eyes, the nose, or the mouth as you work on the adjoining planes.

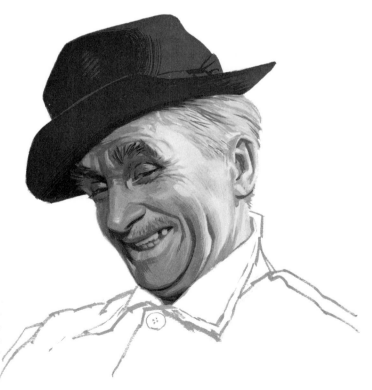

Now add your lights and darks. Remember that you can turn the painting in any direction that will facilitate the sweep of your strokes. Use thin paint for the modeling to prevent the features from becoming completely obscured. If by chance they do get lost, just flip back the drawing and retrace the features.

In case you've been following my suggestion to work the same size as the pictures in the book, let's have a change of pace and render a big head. The scale you finally use in your own work is up to you. When your art is to be reproduced, it doesn't really matter whether you paint large or small, because your work can be enlarged or reduced photographically.

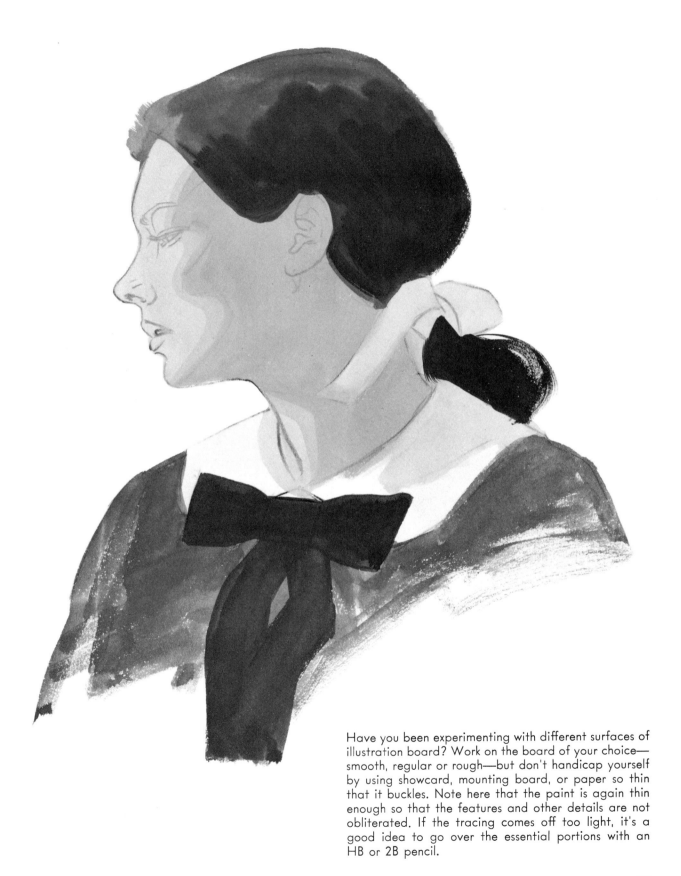

Have you been experimenting with different surfaces of illustration board? Work on the board of your choice—smooth, regular or rough—but don't handicap yourself by using showcard, mounting board, or paper so thin that it buckles. Note here that the paint is again thin enough so that the features and other details are not obliterated. If the tracing comes off too light, it's a good idea to go over the essential portions with an HB or 2B pencil.

55

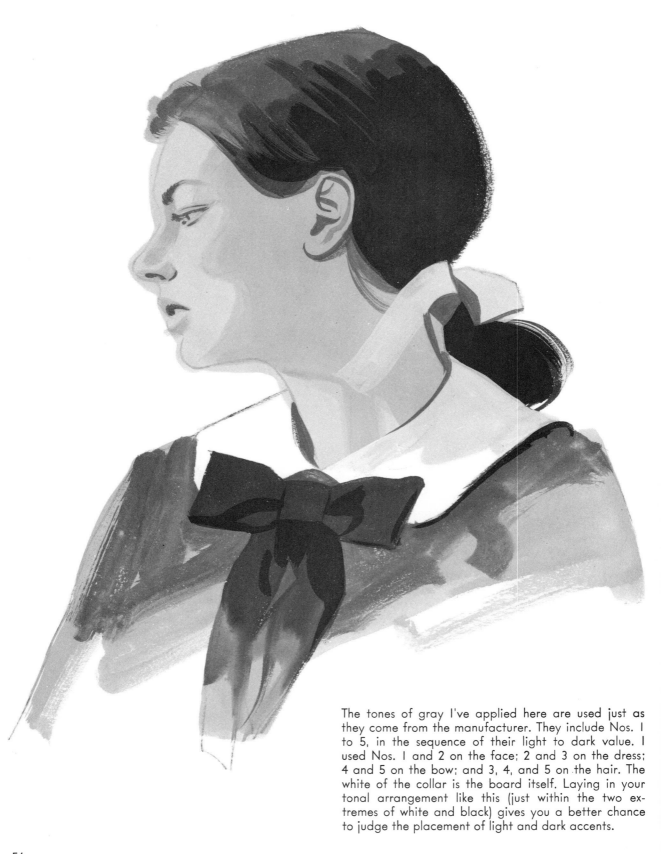

The tones of gray I've applied here are used just as they come from the manufacturer. They include Nos. 1 to 5, in the sequence of their light to dark value. I used Nos. 1 and 2 on the face; 2 and 3 on the dress; 4 and 5 on the bow; and 3, 4, and 5 on the hair. The white of the collar is the board itself. Laying in your tonal arrangement like this (just within the two extremes of white and black) gives you a better chance to judge the placement of light and dark accents.

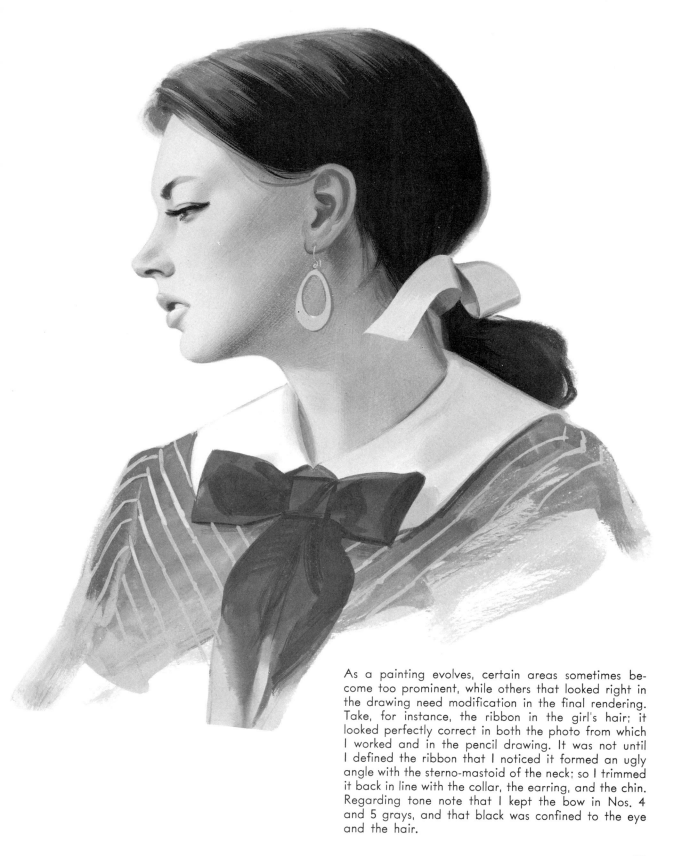

As a painting evolves, certain areas sometimes become too prominent, while others that looked right in the drawing need modification in the final rendering. Take, for instance, the ribbon in the girl's hair; it looked perfectly correct in both the photo from which I worked and in the pencil drawing. It was not until I defined the ribbon that I noticed it formed an ugly angle with the sterno-mastoid of the neck; so I trimmed it back in line with the collar, the earring, and the chin. Regarding tone note that I kept the bow in Nos. 4 and 5 grays, and that black was confined to the eye and the hair.

Project 15: Experimenting with Different Surfaces

Since I want to leave nothing to chance, I'll mention a point that your own logic and intelligence may already have perceived: the paint we use is influenced not only by the particular tool which applies it, but also by the surface which receives it. Consequently, when you wish to achieve a special effect, you must carefully consider both the brush (or other tool) most likely to render it *and* the ground that will help you obtain the effect. As you experiment, you'll find that each type of paper or board takes paint differently and creates its own unique "look."

For the next few pages, we'll work with different surfaces in order to discover some of the ways papers and boards behave and some of the techniques which enhance the unique qualities of these various surfaces. Try out the examples I've devised, and then continue to experiment on your own. File these experiments away for future application.

Here I used an ordinary shirt board (the thick, coarse, gray type) over which I painted with flat bristle brushes for the broad areas, and a No. 3 watercolor brush for small details. The grays on the face are mostly the untouched board, covered here and there with lighter and darker tones to model the features.

This portrait sketch was done on a gesso panel. I exclusively used black straight from the tube, diluting it with water for the grays. The white lines in the hair were incised with a razor blade—a procedure which can be carried out over either wet or dry paint to achieve this effect.

This line drawing was done with a No. 3 watercolor brush and black opaque on a pebbled mat board.

I achieved this luminous effect with middle and dark tones rendered over a previously painted white surface.

I obtained this effect by using flat and pointed sable brushes on a gray charcoal paper. The pigment is black, diluted with water for the grays; and the highlights are rendered in white opaque.

The drawing at the upper left was accomplished with a No. 3 watercolor brush and black opaque on canvas skin paper. The profile drawing at the lower left was rendered on blotting paper, again with a No. 3 watercolor brush and black opaque. For the unusual, soft effect at the lower right, I used a 1½" flat bristle brush to apply a gray tone. When it was dry, I transferred the drawing on top of the tone, and then worked the darks and lights over it with a No. 3 watercolor brush, using a drybrush technique.

Project 16: Painting the Female Nude

From the first gropings of the art student to the last decisive strokes of the master, the feminine form provides an inexhaustible source of inspiration. The flowing lines, formal rhythms, and combinations of color and texture in the nude seem to encompass all that is lovely to the eye. The female nude is a subject that is eternally in demand for both fine and commercial artists. The chap who can do a creditable job on this subject will never lack a patron if he's a painter, or a client if he's an illustrator.

For both aesthetic and practical reasons, then, no artist's training is complete without a serious study of the female nude. No matter what your present circumstances, set yourself the task of mastering figure drawing. Attend life classes at a local art school in the evening, or seek instruction from a private art teacher. If your town offers neither possibility, then enroll in a correspondence school.

Form a definite plan of study. Devote six months to the figure as a whole, followed by six months of concentrated study on the head alone. Then give six months to the torso and its relation to the limbs, and another half year to the hands and feet. The awesome complexity of the figure will be easier to assimilate if you work in small sections.

Your final task is to carefully observe and learn to render the proportion of one part of the body to another—not as the parts really are, but as they should be. Here's where the artist in you is given free expression. Take what nature has to offer and refine it in every way possible to fulfill an ideal sense of beauty. You may find yourself making a head smaller, a waist slimmer, shoulders narrower, hips wider, feet smaller, fingers longer.

I must curb my desire to enter into further discussion of life drawing and remind myself that our primary task here is to learn to apply paint. But there are many books which will help you considerably. Some excellent sources of information are: *Dynamic Anatomy* by Burne Hogarth; *How to Use the Figure in Painting and Illustration,* by Henry C. Pitz; *Drawing Lessons from the Great Masters,* by Robert Beverly Hale; *Drawing the Human Head,* by Burne Hogarth. I recommend that you borrow them from your library or purchase as many as you can for convenient reference. For the moment, do the best you can. Concentrate on the painting procedures in the following demonstration, and develop your life drawing skills when you can give them your full attention.

By this time I'm sure I could omit carrying out the preliminary steps, but I'll continue to outline the procedure for a while longer. So again, begin with a drawing of the subject; trace the big shapes; fill them in with flat tones; trace details on top of the flat tones; and finally, model the forms and render the details.

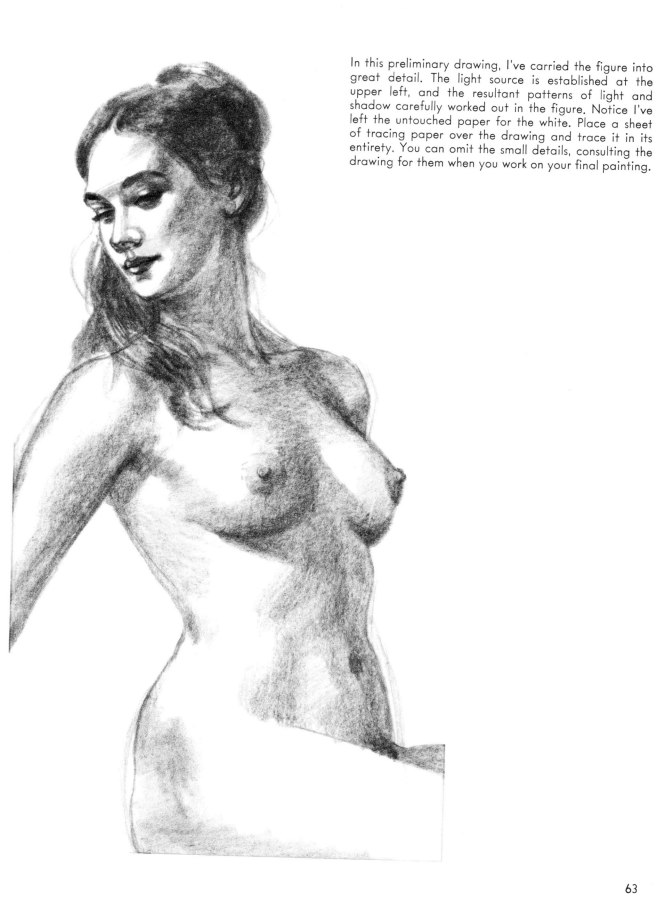

In this preliminary drawing, I've carried the figure into great detail. The light source is established at the upper left, and the resultant patterns of light and shadow carefully worked out in the figure. Notice I've left the untouched paper for the white. Place a sheet of tracing paper over the drawing and trace it in its entirety. You can omit the small details, consulting the drawing for them when you work on your final painting.

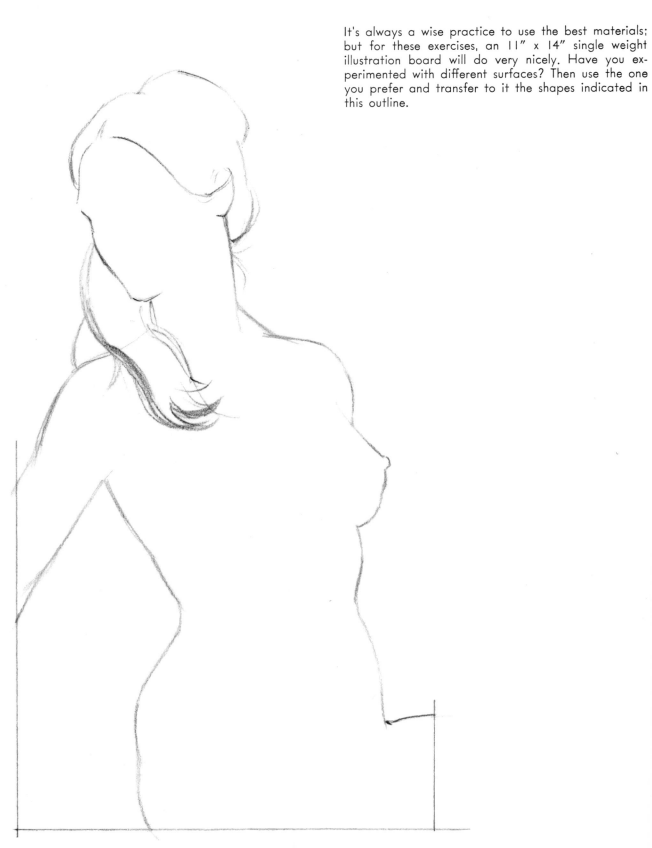

It's always a wise practice to use the best materials; but for these exercises, an 11" x 14" single weight illustration board will do very nicely. Have you experimented with different surfaces? Then use the one you prefer and transfer to it the shapes indicated in this outline.

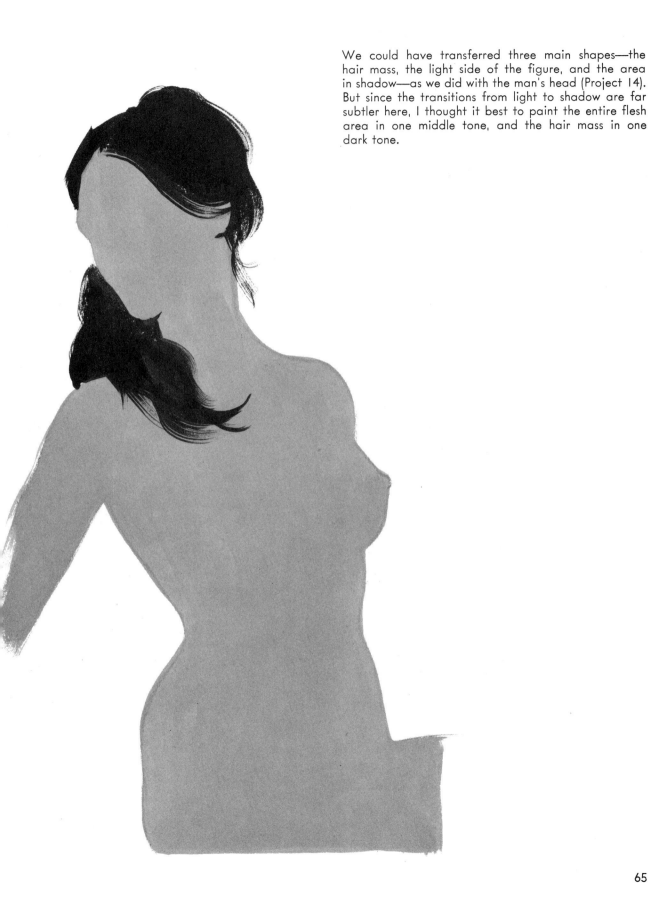

We could have transferred three main shapes—the hair mass, the light side of the figure, and the area in shadow—as we did with the man's head (Project 14). But since the transitions from light to shadow are far subtler here, I thought it best to paint the entire flesh area in one middle tone, and the hair mass in one dark tone.

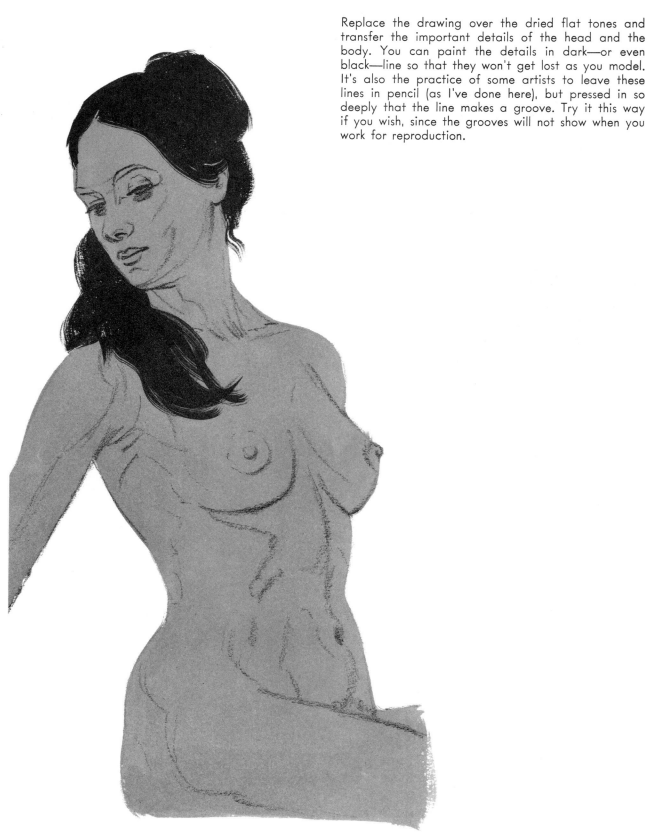

Replace the drawing over the dried flat tones and transfer the important details of the head and the body. You can paint the details in dark—or even black—line so that they won't get lost as you model. It's also the practice of some artists to leave these lines in pencil (as I've done here), but pressed in so deeply that the line makes a groove. Try it this way if you wish, since the grooves will not show when you work for reproduction.

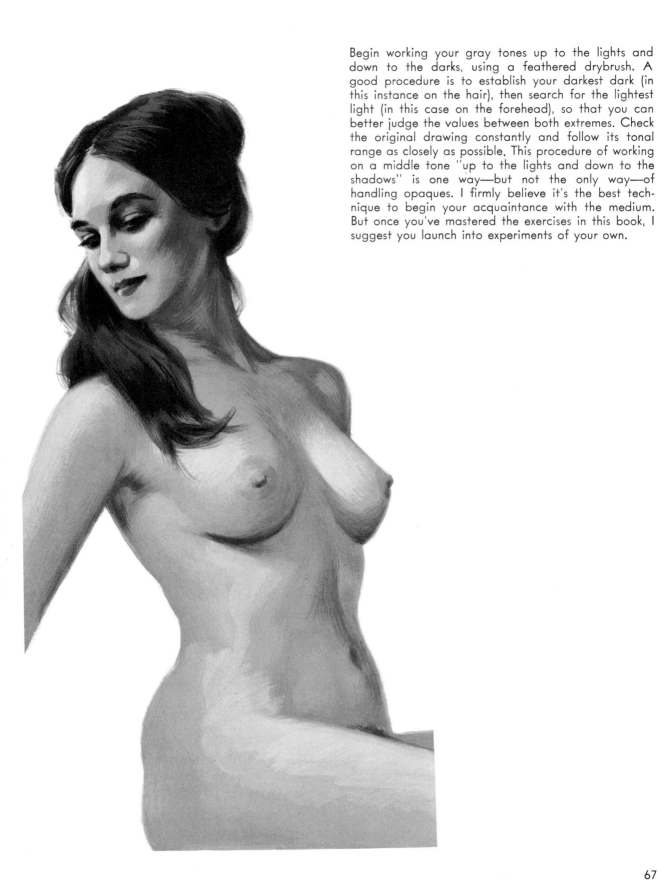

Begin working your gray tones up to the lights and down to the darks, using a feathered drybrush. A good procedure is to establish your darkest dark (in this instance on the hair), then search for the lightest light (in this case on the forehead), so that you can better judge the values between both extremes. Check the original drawing constantly and follow its tonal range as closely as possible. This procedure of working on a middle tone "up to the lights and down to the shadows" is one way—but not the only way—of handling opaques. I firmly believe it's the best technique to begin your acquaintance with the medium. But once you've mastered the exercises in this book, I suggest you launch into experiments of your own.

Project 17: Painting Hair

There's a tendency on the part of professional artists to forget how difficult it is for students to solve certain painting problems. The artist just picks up a brush and starts painting without considering that what he's doing automatically may be obscure and perplexing to the beginner. I, too, would be guilty of this oversight, had not my own students asked how to do what I thought needed no demonstration.

The rendering of hair often poses a huge problem for students. Hair is actually very easy to do, once you approach it in a logical sequence and prepare your brush in the proper manner.

Splitbrush and drybrush techniques play an important role in rendering hair. A splitbrush is similar to a drybrush, except that it is more heavily charged. Moreover, the splitbrush should contain a greater amount of water than pigment. Dip a brush into a puddle of rather thin opaque and tap it to fan its point somewhat. You'll notice that the hairs group themselves into three or four strands, which we refer to as a splitbrush. Take care not to unload too much pigment when you tap the brush. It's better to carry out this process on a non-absorbent surface such as your painting tray, rather than on paper.

Drybrush, on the other hand, must be fanned and feathered (spreading the tip of the brush to its widest arc) on an absorbent paper such as blotting paper, so that the brush is only sparingly charged. Overloading a drybrush will regroup the hairs and give you a solid stroke. Be sure, too, that the opaque for split and drybrush is thinner than normal; heavy pigment will prevent the hairs from separating into either groups or individual bristles. Drybrush produces a rather soft texture, while splitbrush creates a rather rough, strong texture. Use both techniques to render hair and practice both whenever possible.

You don't have to render any particular thing; thin some opaque, dip, tap, shape, and let yourself go. Loosen up your wrist and get the feel of sweeping, rhythmic strokes. When you paint hair, always sweep your brush toward the highlights. The reason for working toward the highlights is that the pressure is heaviest at the beginning, and lightest at the end of each stroke. So, as you flick the brush and lift it off the paper, it leaves the lightest and softest mark on the edge of a highlight. This technique is suitable whether you're working on a bare illustration board or over a previously painted middle tone.

Avoid the hard edges which result from an overloaded brush (left). Instead, try to create soft edges with a splitbrush or drybrush which is scantily charged with thin paint (right).

Your strokes should sweep toward the highlights, as they do here. Turn the drawing in any direction you choose to facilitate the spontaneous and rhythmic flow of strokes.

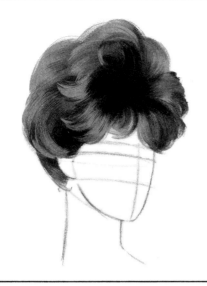
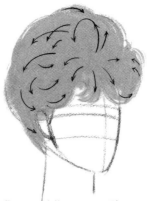

First apply the flat middle tone. Then use drybrush and splitbrush techniques to add the lights and darks in sweeping strokes, following the directions shown in the diagram.

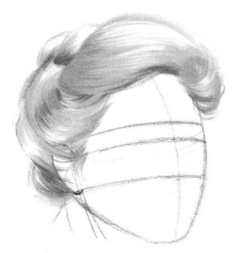
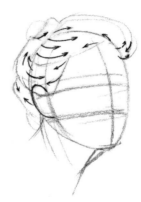

To depict white hair, apply light gray drybrush and splitbrush strokes to the bare illustration board, following the directions indicated.

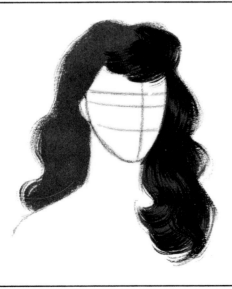

To depict brunette hair, begin with a dark middle tone. Then apply your darks in sweeping strokes over this flat tone, using the same procedure as before, and following the directions indicated.

Project 18: Painting Animals

Animals have been a favorite subject of artists since time immemorial, as the ancient cave paintings in Spain and France attest to this day. It's easy to understand the fascination that animals have held for man through the centuries. They're exciting to portray. An artist needs a great deal of knowledge and understanding not just to make a correct graphic statement, but also to capture and interpret the character, attitude, and behavior of an animal: the strength, speed, and agility of a horse; the docility, alertness, and devotion of a dog; the cunning, slyness, and ferocity of a lion.

Is it any wonder that animal painting has elevated so many artists to prominence? If there's an inclination on your part to join the illustrious list, go to it —and best of luck. The path is the same as to any worthwhile goal; unfaltering determination, willingness to work hard, and the pluck to overcome whatever obstacles you find on your way to the top.

Speaking of work, let's get back to it right now.

Generally, I prefer to work from life, but since an animal doesn't understand about holding a pose, I find it's much easier to work from photographs when I paint animals. The demonstrations that follow are primarily concerned with the technique of paint application, so the use of photographs is doubly valid. These demonstrations are, you might say, "portraits" of animals. My purpose is to show the different strokes—even the different brushes—required to render long and short haired creatures.

In order to portray any animal in action, the artist must understand its anatomy. Even when he's working from a perfect action photograph, he must still be able to "read" the underlying bone and muscle structure, add a hidden portion, or fill in a detail lost in shadow. Get books on the subject; visit the zoo; observe your cat or dog; and sketch, sketch, sketch.

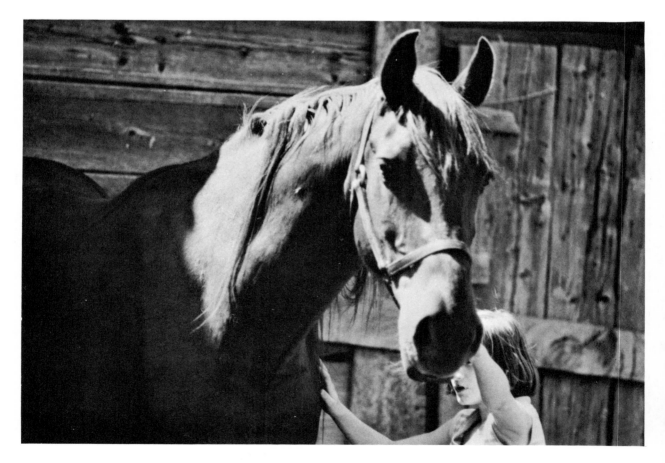

Here's the original uncropped photograph from which I worked. Notice the very strong contrast between light and dark.

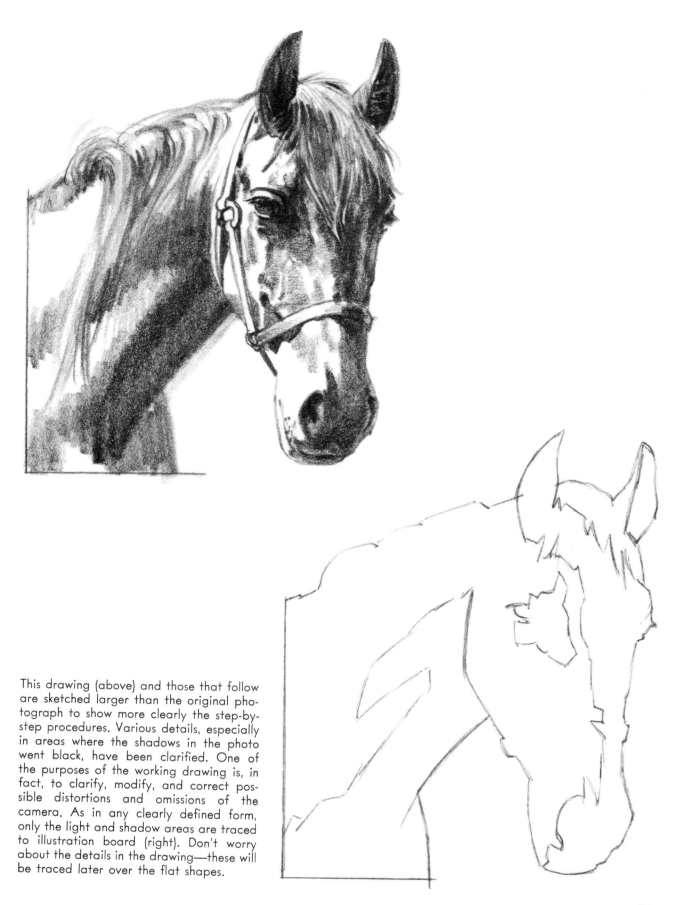

This drawing (above) and those that follow are sketched larger than the original photograph to show more clearly the step-by-step procedures. Various details, especially in areas where the shadows in the photo went black, have been clarified. One of the purposes of the working drawing is, in fact, to clarify, modify, and correct possible distortions and omissions of the camera. As in any clearly defined form, only the light and shadow areas are traced to illustration board (right). Don't worry about the details in the drawing—these will be traced later over the flat shapes.

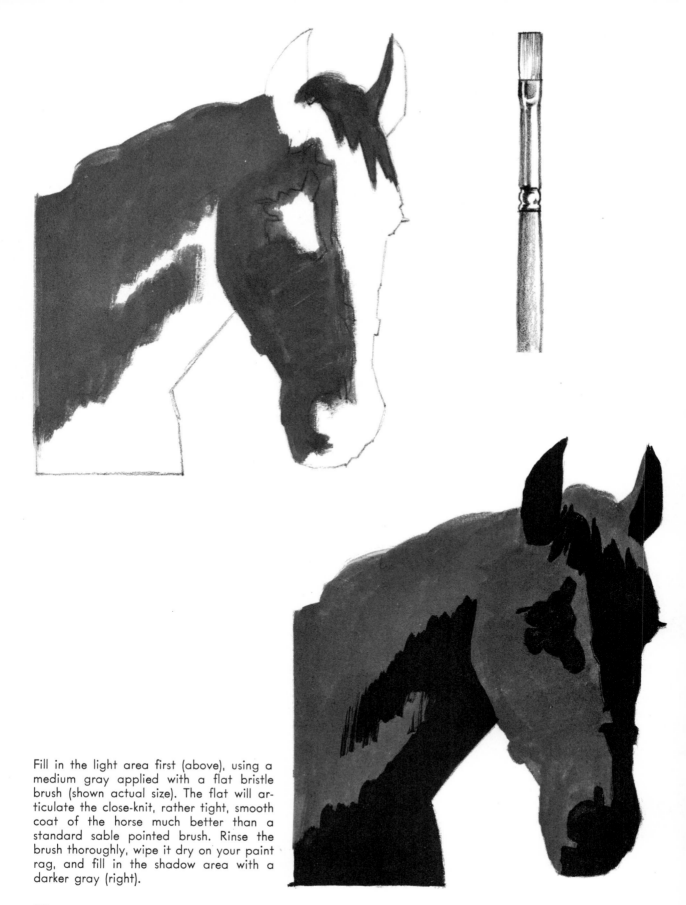

Fill in the light area first (above), using a medium gray applied with a flat bristle brush (shown actual size). The flat will articulate the close-knit, rather tight, smooth coat of the horse much better than a standard sable pointed brush. Rinse the brush thoroughly, wipe it dry on your paint rag, and fill in the shadow area with a darker gray (right).

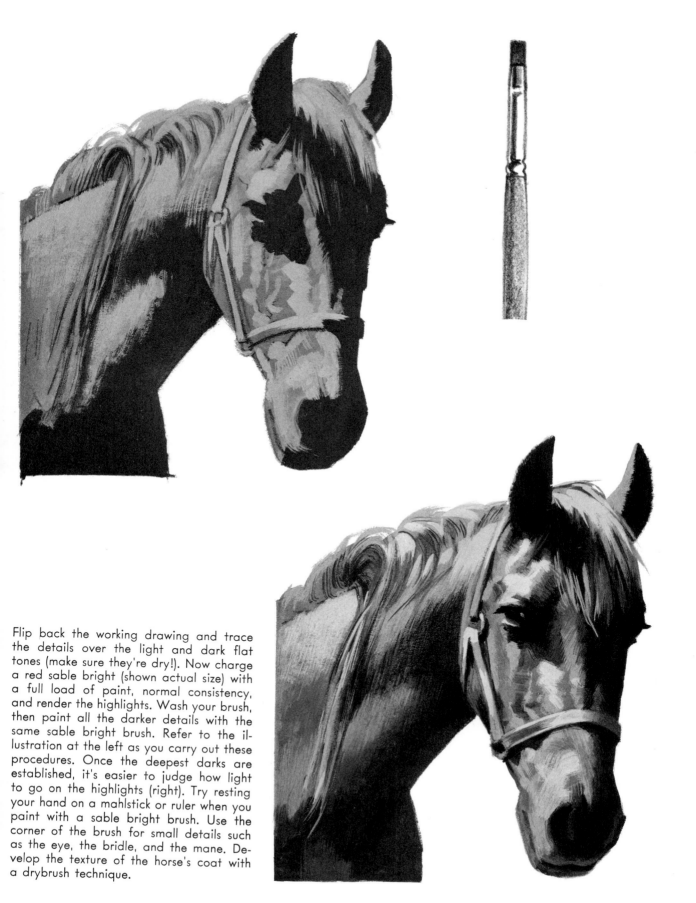

Flip back the working drawing and trace the details over the light and dark flat tones (make sure they're dry!). Now charge a red sable bright (shown actual size) with a full load of paint, normal consistency, and render the highlights. Wash your brush, then paint all the darker details with the same sable bright brush. Refer to the illustration at the left as you carry out these procedures. Once the deepest darks are established, it's easier to judge how light to go on the highlights (right). Try resting your hand on a mahlstick or ruler when you paint with a sable bright brush. Use the corner of the brush for small details such as the eye, the bridle, and the mane. Develop the texture of the horse's coat with a drybrush technique.

73

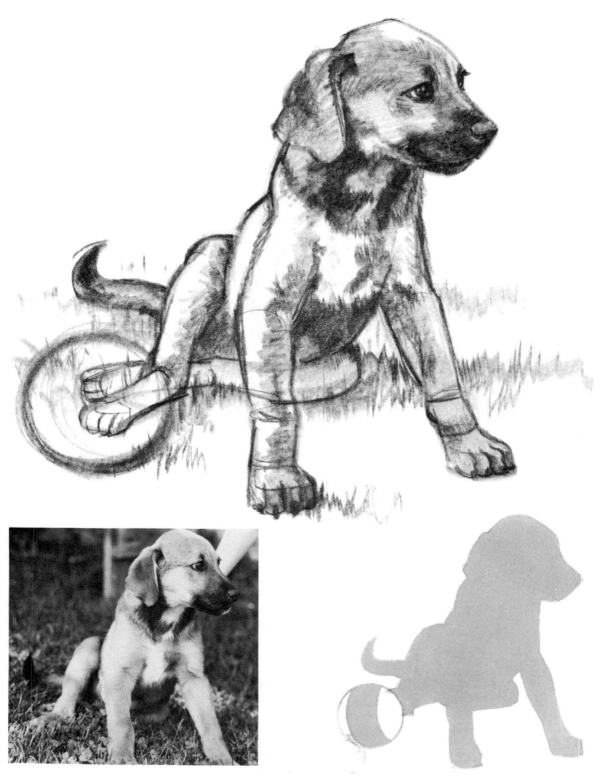

I've concentrated the entire step-by-step procedure in this demonstration onto two pages so that you can easily follow it at a glance. First, I sketched the drawing (top) from the photograph (bottom left), being careful to add the details cropped by the camera or lost in the grass. Then I noticed three unpleasant prongs formed by the hind legs and forelegs of the puppy. I covered one with a ball to rectify the composition (bottom right). Since the dark areas in the drawing are relatively small, I painted the puppy entirely in the light gray shown here, using a pointed sable watercolor brush.

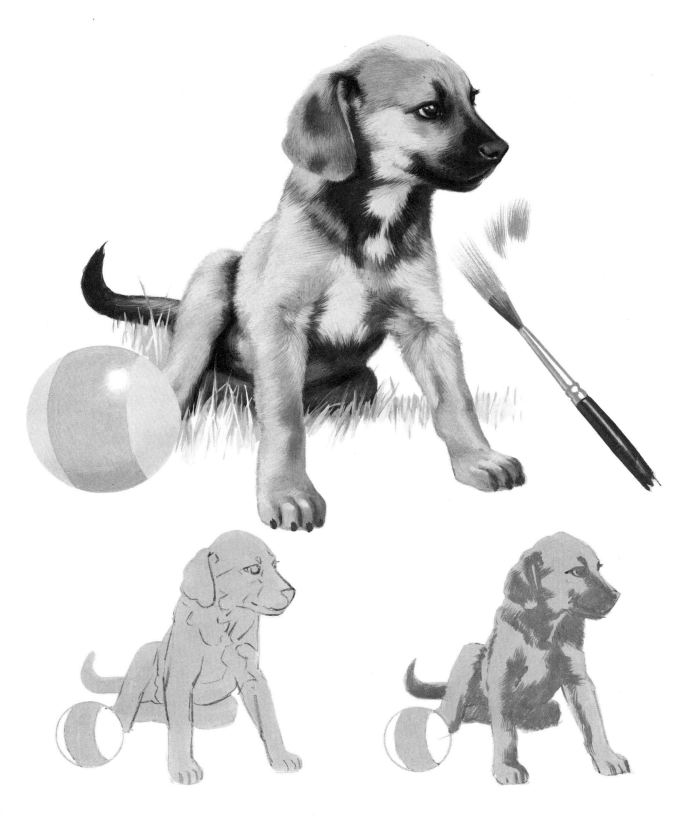

When the flat tone was dry, I traced the details over it in pencil (bottom left). Then I rendered the darks in a middle gray, feathering my pointed sable brush in a drybrush technique to create the soft, furry texture of the puppy's coat (bottom right). Using the same technique, I worked down to the darks and up to the lights (top). Study each area of the painting and follow the application of the paint. Notice and try to duplicate the short strokes on the head, the long strokes on the chest and shoulders.

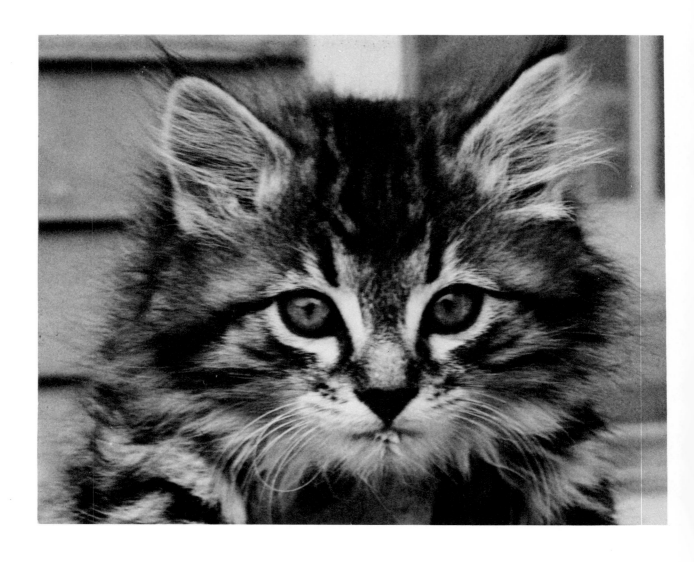

The preceding demonstration was carried out completely on two facing pages to capsulize its development. This demonstration will take up six pages to show its step-by-step progression in as large a scale as possible and to reproduce the drawings and paintings actual size. To paint this cat, begin as usual. Study the photograph (above), compare it to my sketch (right), and then copy the drawing.

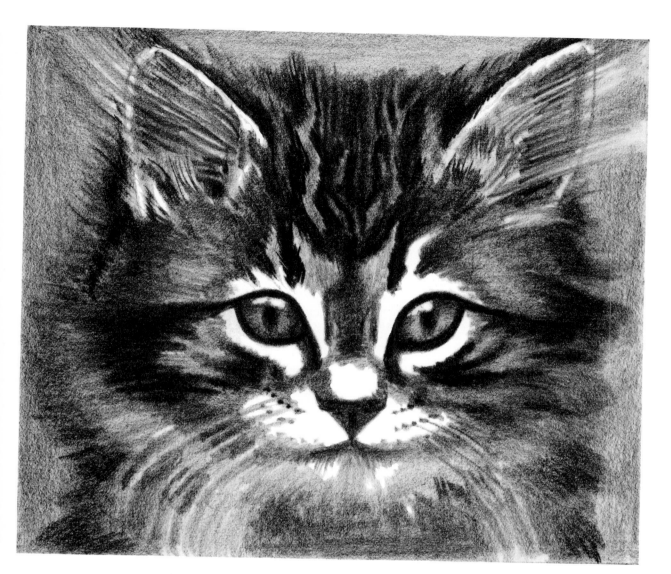

Before you trace your drawing, I want to introduce you to toned or colored paper—one of the most exciting approaches to opaque watercolor. This rectangular shape (left) is a piece of toned paper which I've glued to cardboard (I prefer glue; rubber cement swells when the paint is applied). To avoid the gluing procedure entirely, you can purchase colored mat boards. They offer a medium surface that is inviting to opaques and are available in a variety of colors—from soft pastel tints to brilliant primary hues. I'll be using this toned paper in the following demonstration.

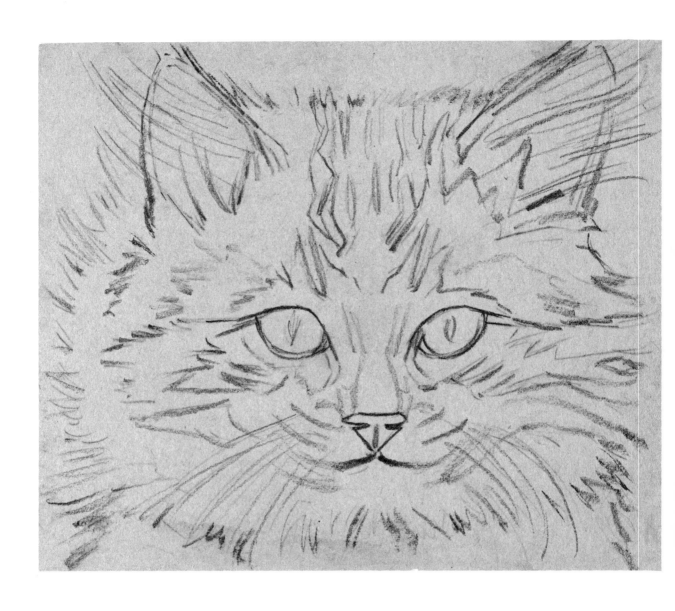

When you've selected the toned or colored paper you'd like to use, trace the entire drawing of the cat— including the most important details—as I've done in this sketch.

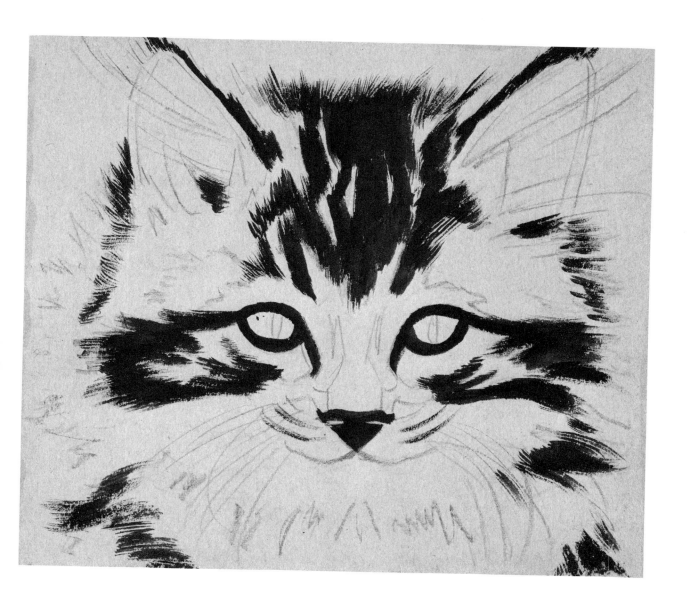

Since the paper itself serves as the middle tone, set down the black passages first, taking care to avoid creating any hard edges even in these first strokes in order to preserve the softness of the kitten's fur. The tool again is a pointed watercolor brush. Unless otherwise indicated, it's the type of brush used in all the demonstrations.

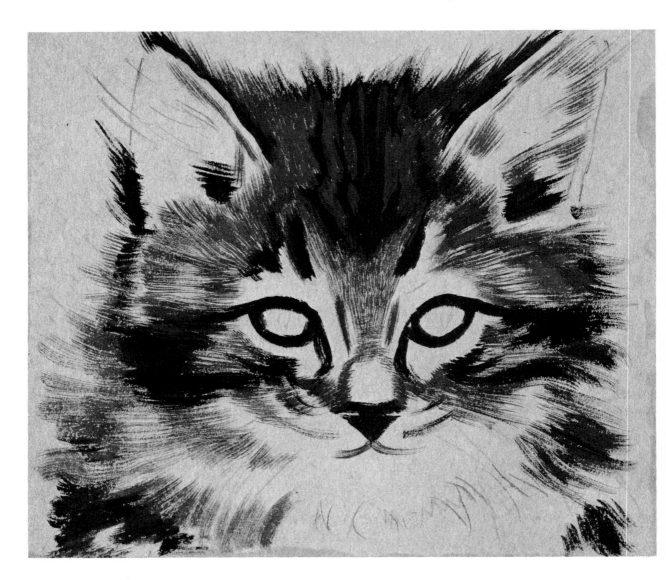

Using the same size brush as the one shown here, practice drybrush stroking in the directions indicated, turning the paper whatever way you please to facilitate the effect. When you've gotten the knack, match the darker gray shown in the palette on the facing page and start to drybrush the cat's fur, using the model above to guide you.

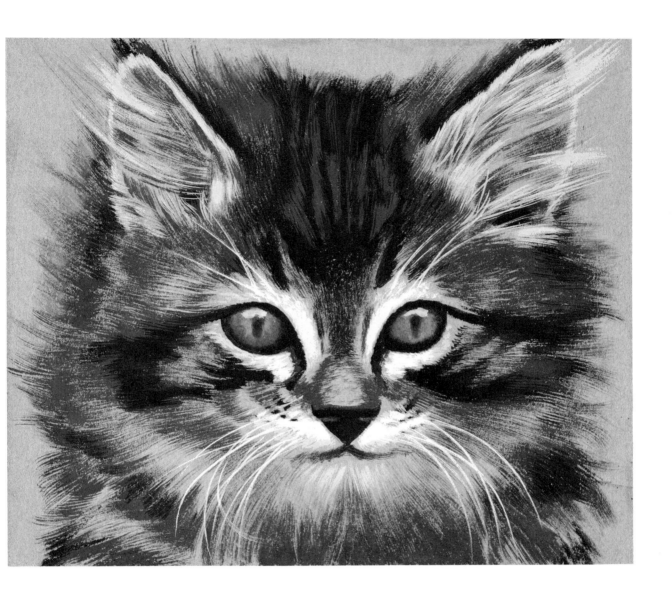

Continuing with the drybrush technique, work up to the lights and add the details. There you are. With a toned paper and only two shades of gray, plus black and white, you've painted a kitten in full tonal scale. (Incidentally, I used the light gray in just one place, the ears.) If the kitten's fur looks a bit wiry or stiff in spots—as it did in my painting—then soften them by stroking a clean, damp, feathered brush over the offending areas.

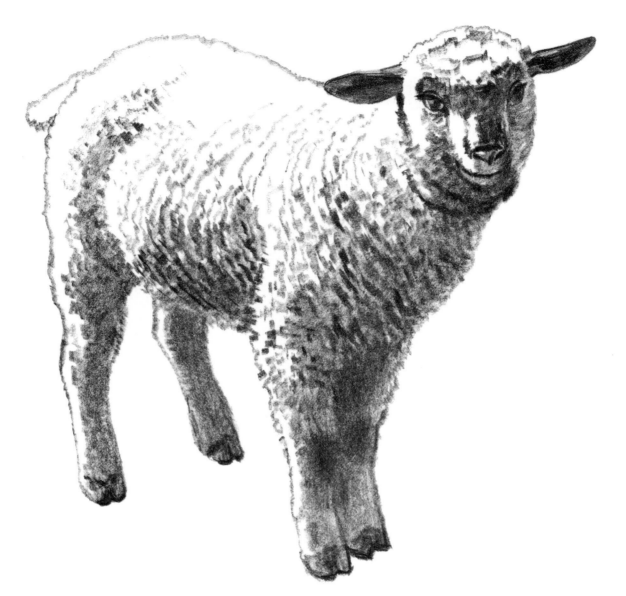

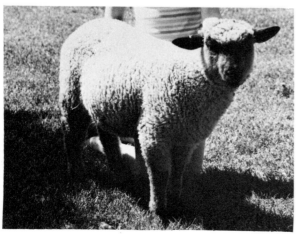

It's up to you to take your own photographs or to hire a professional to do the job. The better the photos you use for reference, the easier it is to do the drawing. I work on the premise that the importance of the commission reflects the quality and number of shots to be taken. This photograph was just a casual shot, in which much of the detail—especially in the head—was lost in shadow. I had to reconstruct these missing parts from memory and from my knowledge of anatomy when I actually began to sketch the pencil drawing you see here.

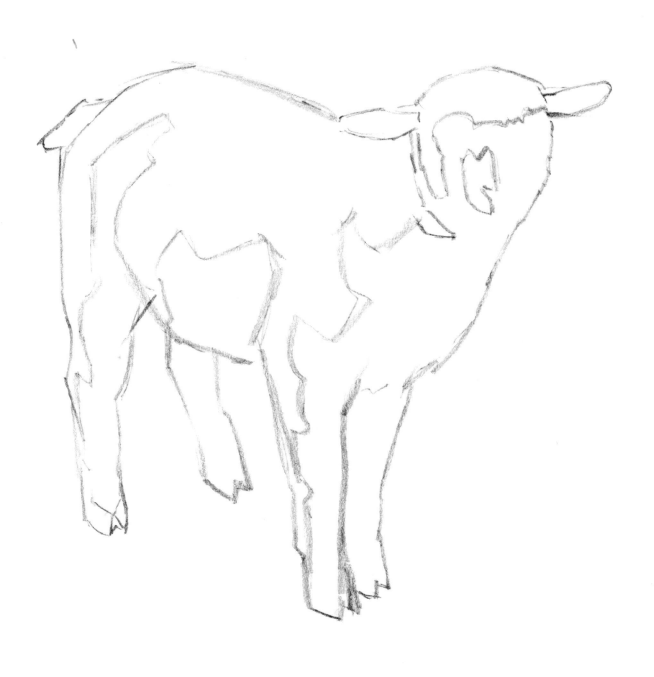

This traced drawing shows the shapes which will be painted in shadow and the light areas which will be left untouched. Let me explain. If you flip back to the beginning of the animal section, you'll notice that lighter values were applied on top of darker ones. This technique is often correct, but when the occasion arises to use the paper itself as the lightest value, there's nothing to stop us. In this case, where the drawing of the lamb has large areas of white, the logical thing to do is put the paper to work.

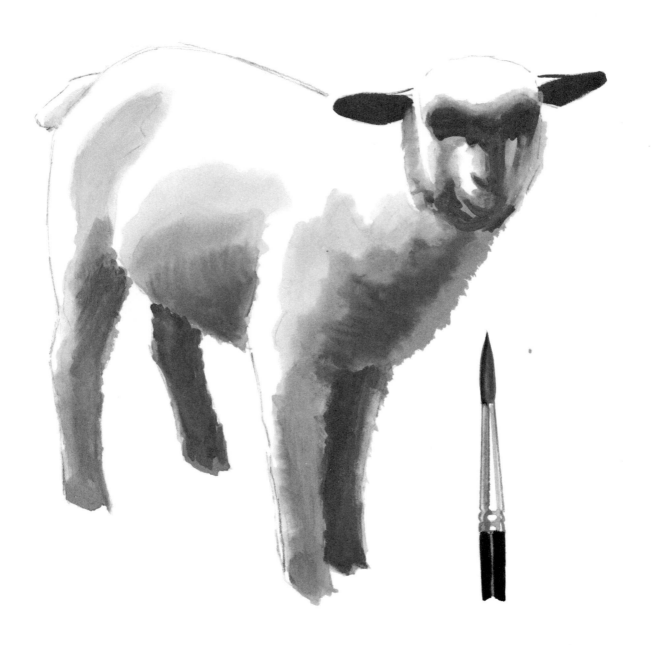

The sole purpose here is to establish only the basic form of the lamb, without any attention given to detail. Notice that the tones are blended wet-in-wet. To create this effect, use a pointed sable brush (same size as the one shown), and apply the lightest gray to one area. Have a second brush prepared in advance and loaded with a darker gray, so you're ready to begin at the edge where the lighter tone leaves off. Fuse the two together in a soft transition of tone (left). While the second gray is still wet, apply the third tone, following the same procedure. Apply this wet-in-wet method to one area at a time—girth, throat, shoulders, legs, etc. The wet-in-wet blending task will be easier to execute if you thin your opaque.

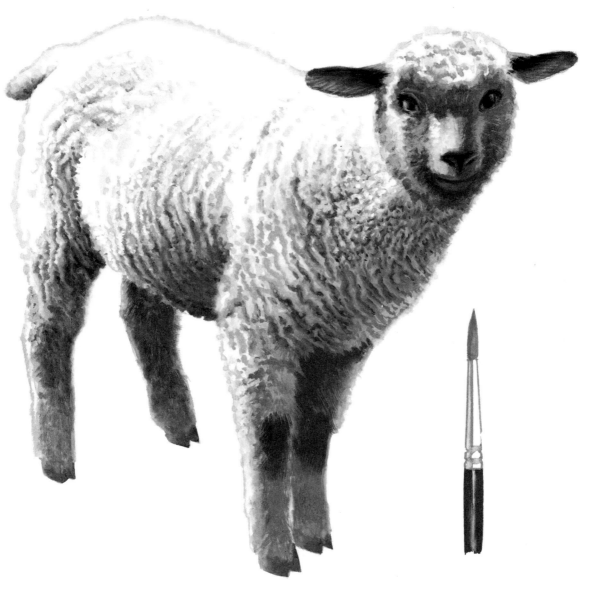

Now switch to a smaller sable brush (same size as shown) and begin to articulate the wool. Rendering the wool will be quite simple if you follow my diagram (left). Begin again with the lightest gray in the light area and carry weaving and swirling lines into the shadows, dipping into the darker grays as you do so. Here and there, you'll have to bring white details into the shadows and dark accents into the light, as on the girth and forehead. Since a large part of the torso is untouched white paper, your task is simply a matter of rendering the wool in the shadow areas and finishing up the legs. (Notice the drybrush details on the legs and head). When you're finished, look for hard edges and soften them with a clean, damp brush.

Project 19: Painting Folds and Patterns

It's important for you to be able to analyze and render folds and patterns, for you'll discover they'll come up quite often in your work. I'll discuss folds first because wherever a fold leads, a pattern must be ready to follow. In other words, patterns must abide by the principles that govern folds.

When you draw or paint folds, the first point to remember is that the character of a fold is determined by the thickness or thinness of the material. Observe the simple, broad folds on an overcoat, and compare them with the thin, crisp ones on a blouse. Then keep in mind that the particular character and construction of a fold also depend on the form over which the fabric is draped, and the action of that form. Consider the motionless folds on a tablecloth and compare them to the folds on a man's trousers as he runs. Finally (and this point must *never* be forgotten), folds are not just lines; they are three dimensional forms with a top ridge, a base, and two side planes. Like any other element occupying space, folds must be described with lights, shadows, and cast shadows.

In the section on painting children (Project 20), we'll explore folds done in a linear manner, which nevertheless convey a sense of bulk. But let's stop talking and start doing. That's the only way to learn.

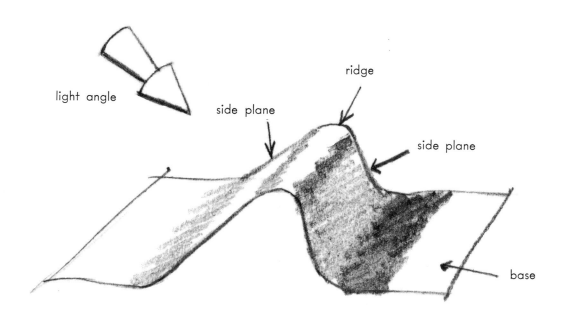

Folds are three dimensional forms with a top ridge, a base, and two side planes. They must be described with lights, shadows, and cast shadows.

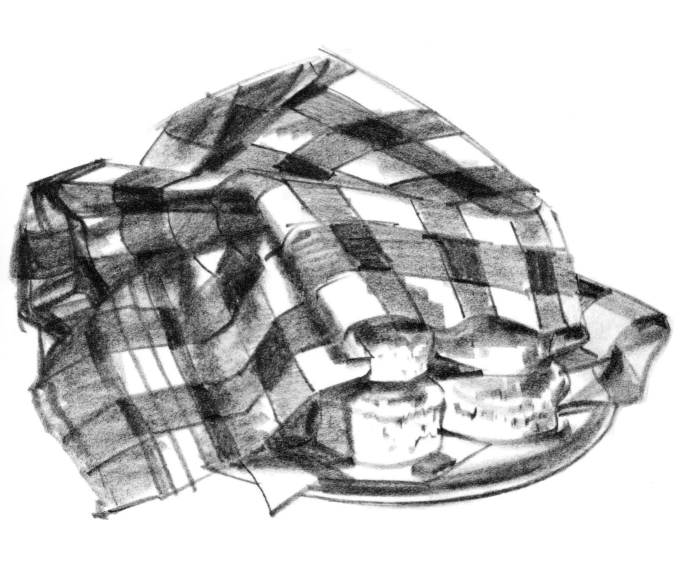

Here's a platter of biscuits covered with a napkin, exactly as my wife brought them to the studio. Certainly not a glamorous subject, but one that lends itself so well to the problems we're about to investigate that I couldn't resist it. Study the folds of the napkin and the checkered pattern it carries. To render both simultaneously would be rather a complicated job, so we'll tackle each topic separately. Whenever (as in this instance) two problems present themselves simultaneously, try to find a way of solving them separately.

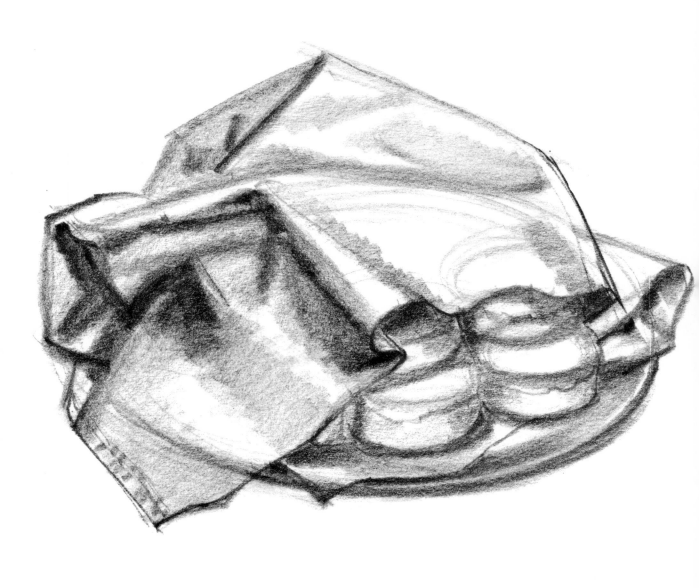

Place a thin sheet of tracing paper over the drawing on the previous page. Draw everything except the checkered pattern so that you can concentrate entirely on constructing and rendering the folds. This approach will give you a chance to get the feel of the cloth as it dips and bulges, or turns and disappears. Folds have bulk and volume; notice how clearly these qualities are revealed by the ridges, sides, and base of the folds above. Try to duplicate them now in your own drawing.

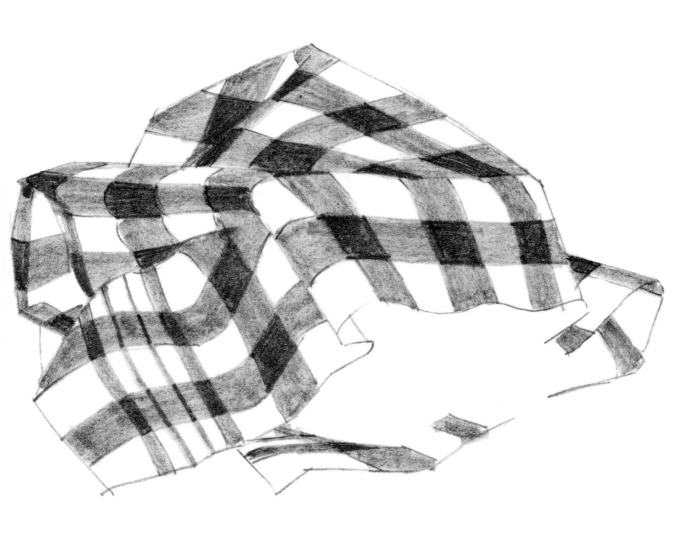

Remove the drawing of the folds which you've just completed. Place a fresh sheet of tracing paper over the original drawing and pick up only the checkered pattern, as I've done here. This diagram clearly illustrates the distribution of the checks as they rise, fall, and follow the convolutions of the cloth. Notice that this drawing simply describes the flat design; no attempt has been made to indicate how the lights and shadows will effect the form and application of dark gray, middle gray, and white values. Now that we've broken the problem down into its two components and solved them separately, we can begin the painting. For the moment, follow this two-step procedure; when you've become more adept at rendering patterns and folds, you'll need no more than one working drawing to execute the painting.

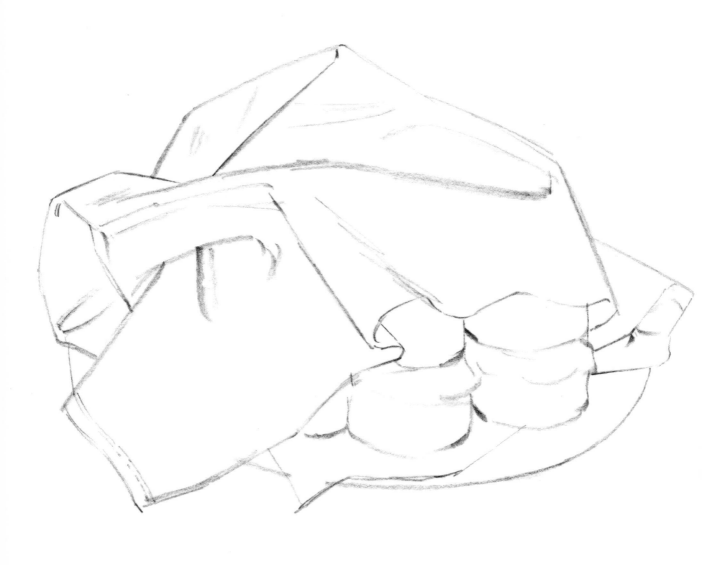

Now trace the dominant folds onto illustration board. Since the master drawing contains all the information we need—including the biscuits—we can remove the actual object serving as a model. Personally, I like to keep everything before me until the picture is completely finished. Subtleties that may have escaped the drawing—like the exact character of an edge or the precise value of a tone as it turns away from the light—are often needed in the painting. Other artists prefer to rely less on fact and more on imagination. Both approaches are valid; it's up to you to decide which is more appropriate to your personal style.

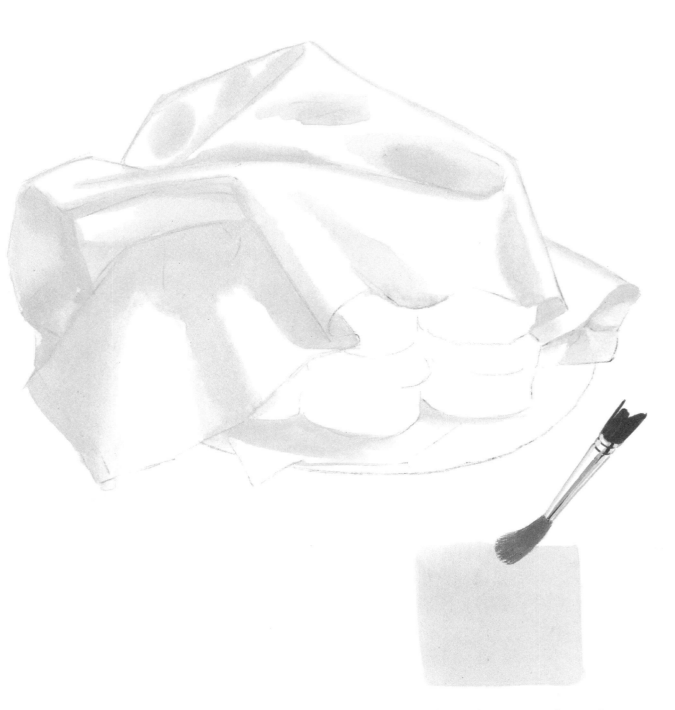

Just as we drew the folds by themselves, so shall we now paint them by themselves. Using the pencil drawing as a guide for the lights and shadows, apply rather thin opaque to one particular area. While the paint is still wet, zig-zag a damp brush (no pigment whatsoever) along the edge of the tone to soften it. Repeat this procedure area by area, using two brushes—one brush for applying the paint, and the other brush for softening the edge, as shown in the small illustration above.

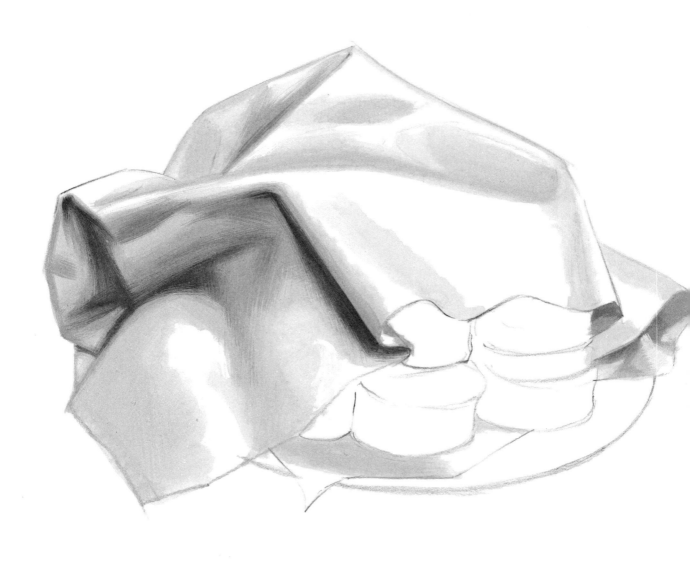

Now drybrush the darker values on top of the light ones. If the napkin carried no pattern, you'd be finished at this point. But you've still got the checks to contend with. If you're beginning to grumble about how laborious this process seems to be, let me comfort you with two thoughts. First, these procedures take longer to explain than to execute. Second, once you've understood each step of this demonstration, you'll be able to apply its lessons to any pattern on any cloth or garment.

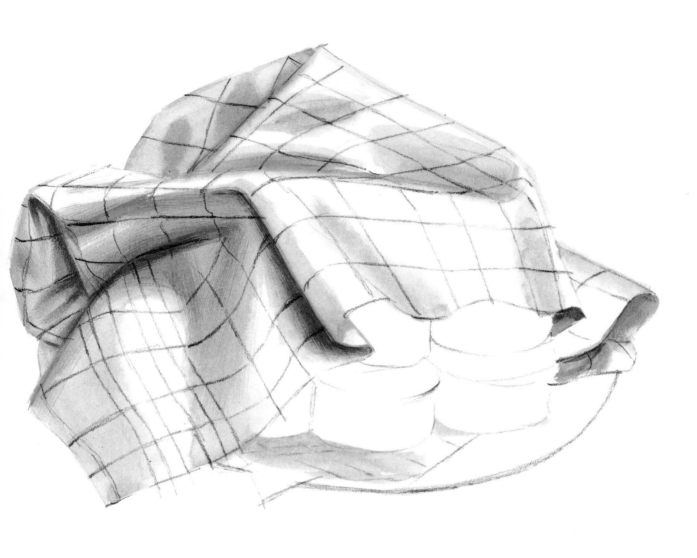

Take the drawing of the checkered pattern and trace it on top of the finished white napkin. A good method to follow when tracing separate drawings over the same painting is to register them into place in the following way: make two or three cross marks on the illustration board (with a ballpoint or ruling pen), just outside the picture area. Position the drawing and tape it to the top of the illustration board. Then ink in the cross marks that show through the thin paper, exactly over the ones underneath. This approach works very well, especially on drawings with precise and intricate details that demand accurate positioning.

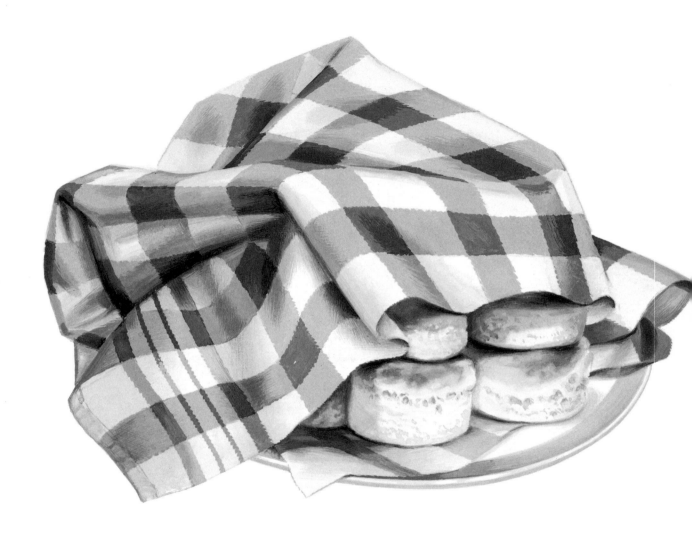

To paint the checks, apply two values—medium gray and light gray—to their respective squares. As you move from light to shadow, lighten and darken your tones accordingly (refer to the value chart on the facing page). Use a drybrush technique to suggest the weave of the cloth on the edge of the checks. Do the biscuits with thin paint, fusing the edges between values with a small, damp brush, as you did to model the lightest part of the napkin. Now that you're finished, you see that what seemed a rather complicated job became a manageable one when each step was taken in its proper order.

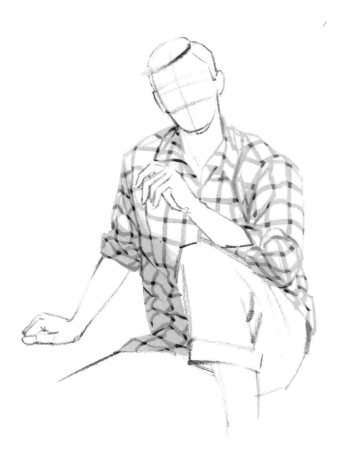

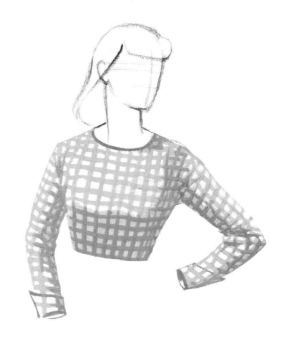

The same laws you've just applied to paint a checkered napkin govern any pattern, whether it's on a shirt or blouse, as illustrated here, or on a wall, a piece of furniture, or anything else. Just remember that a pattern always follows the surface of the cloth, dipping into folds, coming out again, going around the form, and disappearing.

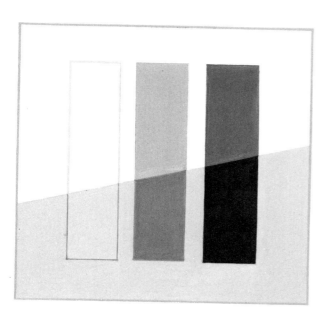

Always remember to select one set of values for the portions in the light area, and another for those in the shadow. The diagram shows the two sets of tones I used for the light and shadow areas of the napkin.

Project 20: Painting Children

With his keener insight, the artist peers deeper into particular worlds and illuminates the wonders in them that none of us could see before. One of these higher spheres beyond the reach or ken of the average man is the world of children.

Is there anything in this world more appealing than a child? It's not in the least surprising that so many artists won't touch another subject. Lucky is he or she who finds a rapport with small fry and can record their antics with perspicacity and understanding—not an easy thing to do, once we've left the fancy and fantasy of the tender years.

There's the problem. The artist who captures the child is the artist who never forgot the wondrous world of his early years. When you paint children, look back into your own childhood and try to recapture some of the magic: the scale of things, for instance, like the giant adults that used to loom over you in those days; the tremendous effort it took to scale the peak that was the sofa, and how once you'd conquered, you became fidgety and scampered on to other adventures; the thrill of teetering on the edge of the precipice that were the stairs; the breathtaking excitement of sliding down the bannister; the endless plain of the living room as you crouched at one end and wondered whether to crawl and reconnoitre the whole tract, or to dash across it in one yippying dash; the strange smell of rubber when your nose was no higher than a tire; the ambrosial taste of an ice cream cone, or the delight of fairytales. Recall the thousand other thrills that a journey, a visit, a relative, a holiday, or the first day at school engendered that live on in memory to this moment. Look back, remember, and paint. I'm quite serious when I say that publishers of children's books and a vast public are eagerly awaiting something charming, engaging and captivating from your recollections.

Ready to solo? You'll have to try it alone sometime; it might as well be now. I've done no preliminary stages here, but only the final painting. By now I'm sure you know the procedure by heart: place a thin sheet of visualizing paper over the painting, trace it, and transfer it to illustration board by rubbing the back of the drawing with graphite pencil or stick (or making a separate "carbon sheet"). Begin painting the flat middle tones. If the pencil indications become obliterated, flip the drawing back over the painting and retrace the details. Articulate the details up to the lights and down to the shadows on top of the middle tones, matching my tones carefully. To keep everything light and airy, the deepest value I've used is dark gray.

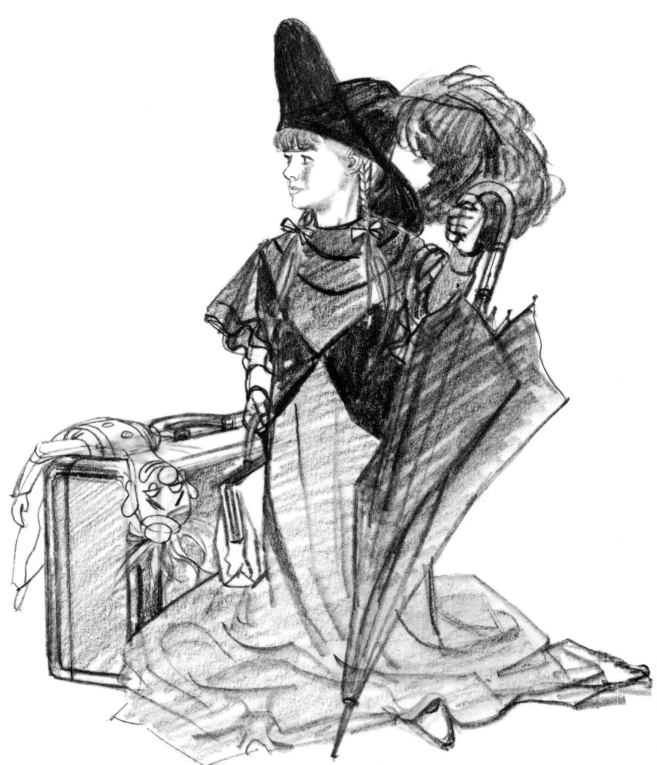

I asked you to try the preceding painting on your own simply to encourage your self-confidence and to allow you to assess your skill. Now let's return to our established step-by-step procedure with this demonstration. The pencil drawing is the final result of several arrangements. The feather originally swept forward, but it destroyed the silhouette of the hat and detracted from the child's face. I discarded some necklaces which made the composition too "jittery," and added the doll to give interest to an otherwise dull area. The point of relating the history of this drawing is to remind you never to trace your drawing onto illustration board until you're completely satisfied that it needs no further alterations or corrections.

As we've done before, trace only the big shapes to be painted first, and only those details that can easily show through the flat tones—the child's face, the doll, and the luggage.

To make sure that no detail gets lost under the first painting, it's often advisable to reinforce some areas with a pen-and-ink line, as shown here. Even though I've already planned to use rather thin paint and to handle it loosely and playfully, I want to make certain that these details show through.

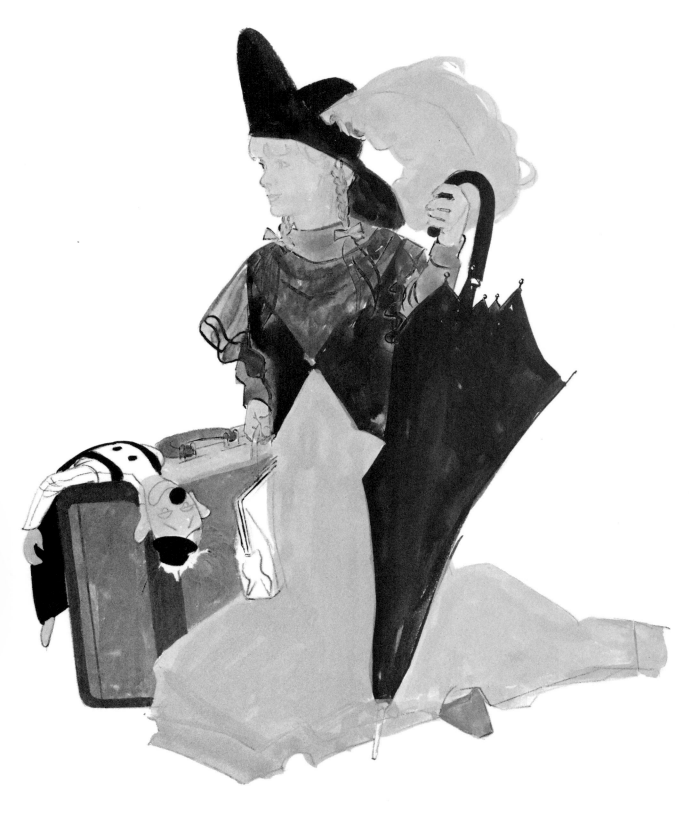

Following those in the original drawing, apply the different values with a medium size brush such as a No. 5 Winsor & Newton. This time, spread the paint freely in all directions so that the result is a number of broken, uneven tones, rather than the smooth tonal shapes we've used before. Any meticulous treatment of line or tone would stifle the carefree, childlike quality appropriate to the subject of the painting.

Place a thin sheet of tracing paper over the original drawing, trace the folds and the details, and transfer this line drawing to illustration board. As I was doing this, it struck me that even though the tones were lively in terms of the textures they represented, the absence of pattern made the picture dull and monotonous. I tried a floral design on the skirt, but this pattern focused too much attention on the garment and not enough on the head. I added a few tentative spots of white on the blouse and immediately knew this was it. The sparkly and effervescent quality was just right for the subject.

Even when we think we've solved every possible problem at the pencil drawing stage, there are times when changes will continue up to the last moment of painting. Try to avoid making major changes, but always be on the watch for small additions or deletions that will project your concept more clearly.

The artist who illustrates children's books has got to be an ingenious fellow. He's expected to produce charming, bright, exciting pictures that delight a child's eye; yet he's rarely allowed the luxury of color because color is terribly expensive to reproduce. The illustrator must therefore devise ways to suggest color, using only black, white, and gray. Line drawing can often solve the illustrator's problem, as we shall see in the following few pages. Instead of following the usual tonal procedure, begin with the pencil drawing; notice it's rendered purely in line.

A great deal of children's book illustration is done solely in line because it's cheaper to reproduce than tone, requiring no halftone plates. Moreover, a linear treatment reflects the way children themselves draw. The little pencil sketch in line on this page was done by my seven year old daughter. (I asked her if it was an angel; she couldn't understand how anyone with half a brain could mistake it for anything but what it clearly was—a cat.) Hopefully, by adopting and adapting children's drawing methods, we make our work more appealing to them. Try this line drawing, using a pointed red sable watercolor brush (I used a Winsor & Newton, No. 3) and black opaque. Vary the pressure of the brush to thicken and thin your line. Notice how line is used on the hat, holster, and shirt of the boy to suggest tone. Line creates the pattern in the girl's playsuit and is also used to render the small patch of grass.

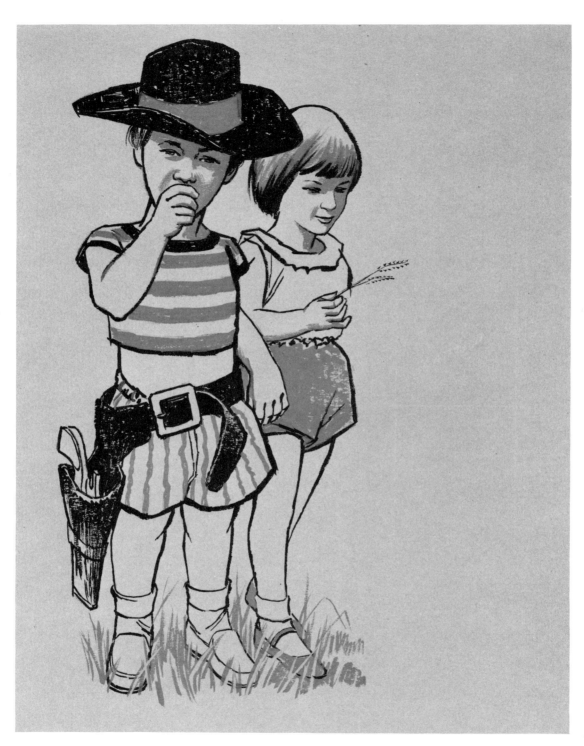

Now do the same drawing, but on a toned paper (the use of toned paper is a frequent device in children's book illustration). Line is quite versatile and can be combined with tone for different effects. Here I've added solid areas of black, plus one tone of gray to the basic line drawing. The paper adds a second tone. The gray areas, of course, could be done in any solid color for added effect. The addition of one color isn't terribly expensive; its cost can often be squeezed into the production budget of a book.

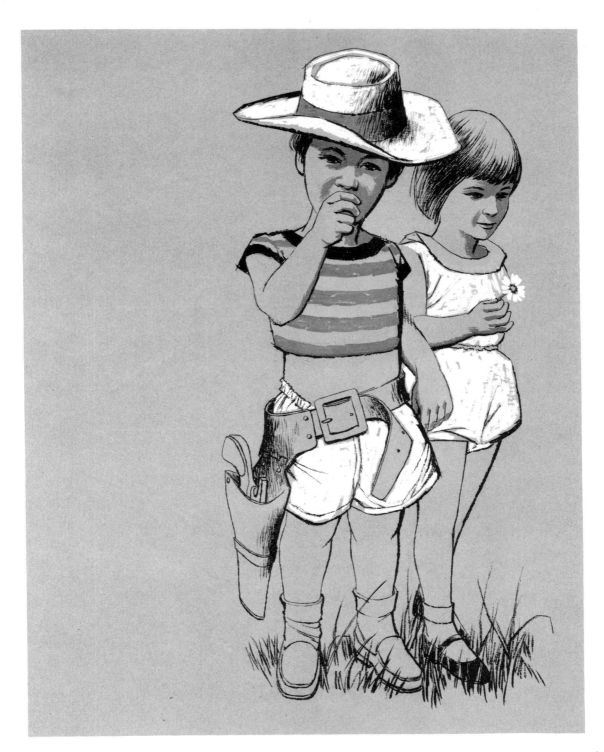

Here's another variation for you to try. To give the basic line drawing sparkle, I added white to three large areas. By using a toned paper, plus white, black, and gray opaque, I created four tones. Here I had a choice. I could have used a white paper, left the hat, shorts, and playsuit untouched (they'd reproduce white), and painted with black and two tones of gray opaque. In this case, however, I thought it would be simpler and more efficient to paint the areas of white directly on the toned gray paper.

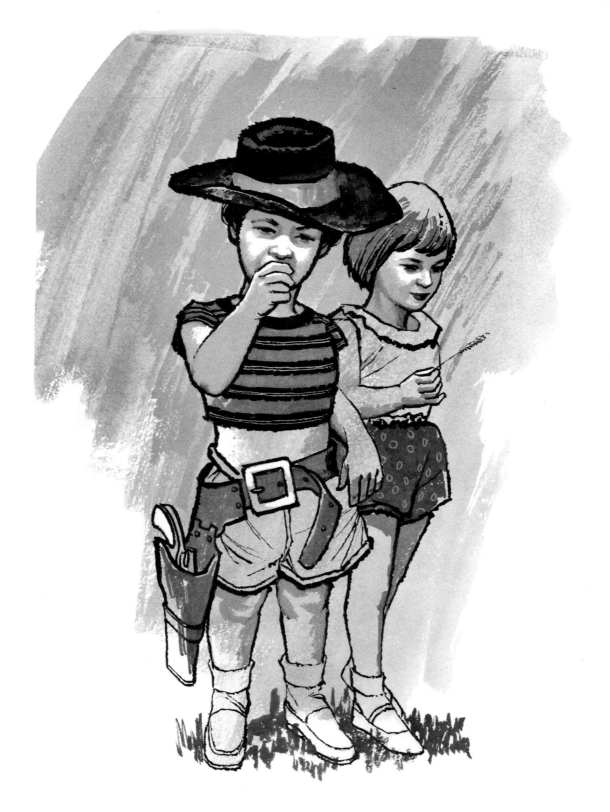

The linear treatment is still prominent in this variation, although I switched back to a white ground and added one more gray. This additional tone was spread over the entire background area in a loose and spontaneous manner. The drawing was then traced on top of it. The background can always be trimmed back with white at a later stage if the shape becomes too large, or if the over-all vignette needs modifications (the "vignette" is the combined shape of the background and the figures).

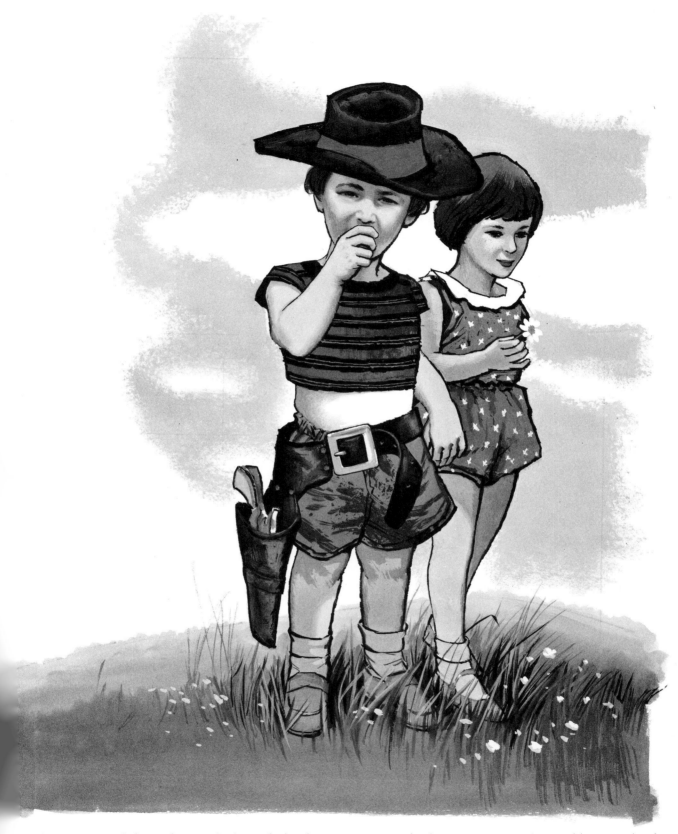

We've progressed from the simple line of the first drawing to the full tonal range employed here. No matter how lavish your use of tone or detail, try to preserve the linear treatment. Line adds a touch of crispness and clarity to this type of work that reproduces well on a great variety of papers.

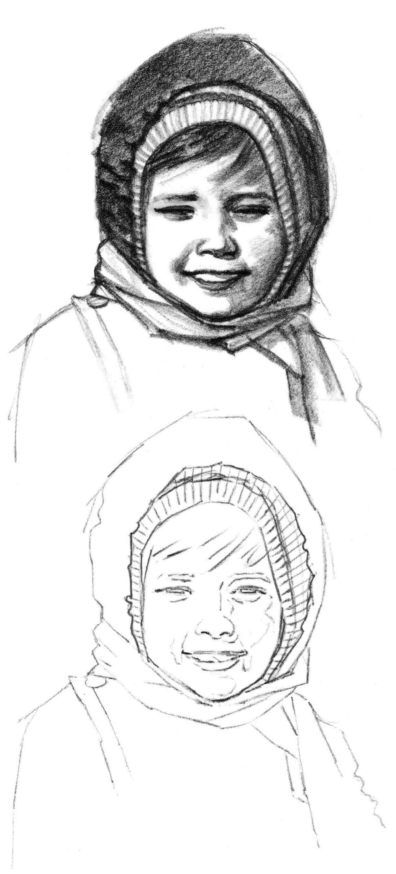

Just to drive home the point that simplicity in children's drawings should be cultivated, let's do one more. We begin with the usual pencil drawing—from life or from a photo.

Trace it to illustration board in all its detail so that you can render it in black just like a line drawing.

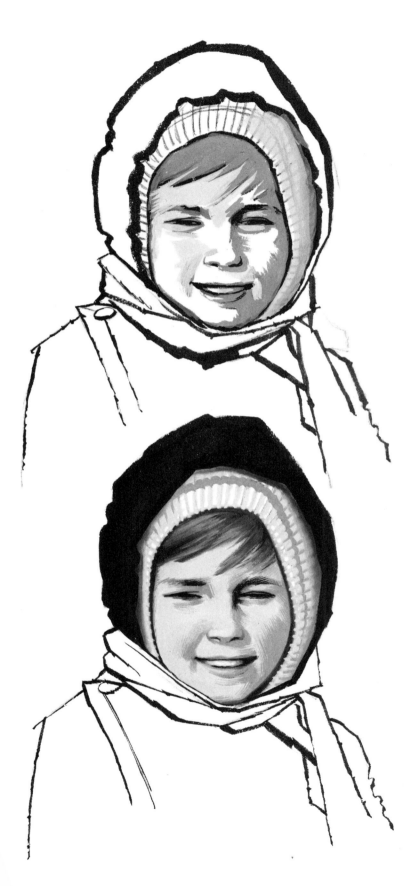

Instead of painting the flat tones first and then adding the details on top, we'll reverse the procedure. Render everything in black line first, so that the drawing is complete and legible. Whatever we add now will only serve to reinforce and enhance the line drawing.

Here are the three values I used, given in the order in which they were applied: black for the line drawing and the shape of the hood; medium gray for the shadow areas; light gray for the lights. Only on the knitted cap, where the light gray was painted before the dark band, did I work from light to dark. The final touches consisted of refining the transitions between the two grays on the face, where I worked one over the other.

Somehow we've fallen into the silly notion that art is one thing—majestic, sacrosanct, and venerable—and lettering quite another—a craft, at best, to be left to the artisan and the journeyman.

As a result, even those students with an innate talent for the art of lettering curb their bent lest they waste their efforts on such an unworthy pursuit. True, with all the mechanical means of reproducing lettering today, the demand for the individual piece of work has subsided. It's wise, perhaps, not to devote one's entire life to an art that is beginning to wither. But surely one can find time to look into a subject so closely allied to painting.

The *total* artist leaves nothing unexplored, and John Donne's observation that "no man is an island . . ." applies more to the artist than to any other man. We're all influenced by the work of our colleagues: in the very act of accepting or rejecting their vision, we focus and sharpen our own.

The type designer, the letterer, and the calligrapher are, in my opinion, to be studied as zealously as any other artist of the highest calibre. It's they who delight in pouncing upon a shape and squashing it, squeezing it, flattening it, or stretching it until it perfectly fulfills a given function. Not content with this achievement, they'll then take a line and again subject it to countless changes so that the combination of perfect shape and proper line becomes a legible, as well as a beautiful, symbol.

Are we to ignore such endeavors toward excellence or remain indifferent to such consummate skill? More "sweat and tears" have been poured over one alphabet than over a score of canvases.

Take a look at the following pages and get acquainted with the rudiments of the art. Try the few exercises suggested and have fun. Confirming once more my assertion that opaques can do anything, you'll need no new tools.

LETTERING CAN BE OF INVALUABLE SERVICE TO THE ARTIST. A TYPE FACE CAN BE AS EXCITING AND EXPRESSIVE AS ANY OTHER KIND OF DRAWING. LEARN ENOUGH ABOUT IT SO YOU CAN INTEGRATE ART & TYPE INTO A WELL-KNIT UNIT!

A B C

Contrary to the popular notion that a straight line is easy to draw, we who letter know better. The ruling method, an approach devised to facilitate drawing straight lines, consists of using a ruler to guide and support your hand as you pull a line with a brush (above). Hold the ruler firmly in place with your left hand. Rest the middle finger of your right hand on the edge of the ruler, and—so the pressure on the brush won't vary—rest your fourth and fifth fingers squarely on the surface of your paper. If you hold the ruler this way, the angle of your brush and the width of your stroke won't vary as your hand slides down. To change the direction of the line, shift the paper (not the ruler) to any position you want. Vertical lines (A) can become diagonal (B) or horizontal (C) by changing the angle of the paper, as illustrated.

Your first attempts will feel awkward, but don't let this discourage you. Practice as often as you can. Load the brush generously with rather thin paint so that it will flow easily. With a No. 3 Winsor & Newton pointed red sable, begin pulling the lines. If the thin lines prove too difficult, apply a bit more pressure to get a slightly bolder line; or change to a smaller or larger brush until you know what size and how much pressure are required to get a certain weight. When you've mastered the straight lines (left), practice the three variations above. First, make "tones" by crossing vertical and diagonal lines over each other. Then, still resting your middle finger on the ruler, wiggle the brush as you come down to achieve the effect in the middle. Finally, to render the last variation, hold the ruler vertically, but slant the connected short strokes.

Now that you know how to pull a straight line, you can begin to letter. Lettering procedures are akin to the painting procedures you've previously adhered to. First, sketch in the general placement and the propor-tions of your letters, as I've started to do at the top. Fill in the over-all mass, roughly indicating the weight of the letters. On a clean tissue laid over this rough, establish the design of each letter in line (bottom).

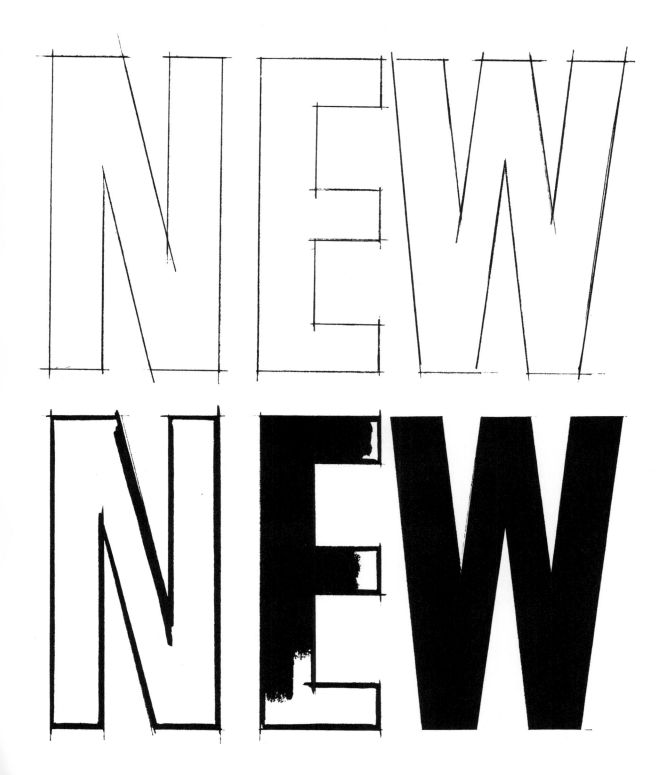

Now trace the letters above, as you would any other drawing. When you letter—even more than when you paint—everything must be exactly right before you apply the paint. A painting can be saved by making alterations; but in lettering, changes made at the painting stage are so obvious that most observers (and all art directors) would detect your muddling.

Over the traced lines, apply the ruling method to the contours and fill in the area with as large a brush as the size of the letters requires. Go slightly past the corners and then trim back with white to assure sharpness—as I've done on the "W" in the bottom diagram.

AEF

Once you've mastered the ruling method, you can immediately letter fifteen of the twenty-six characters in the alphabet. Apply the procedures demonstrated in the preceding pages to form these letters.

HIKLMN

TVWXYZ

There remain only eleven characters to reckon with. Eight of these are composed of combinations of straight and curved strokes (the curves are done freehand). and only three—C, O, and S—must be executed entirely with curved strokes.

BDG

JPQRU | COS

To accomplish curved freehand strokes, begin by lightly penciling in top and bottom guide lines. Then indicate in pencil the strokes shown. Fully charge a No. 3 brush with thin paint, and, moving your entire arm (not just your fingers), begin at the top of the curve, pressing down lightly on the brush. Increase the pressure on the brush toward the middle of the stroke, and decrease it as you finish the stroke. Work in the directions indicated in the illustration. Don't worry about clean edges or meticulous rendering; just feel the flow and rhythm of the strokes.

Another good exercise to develop brush control is to practice rendering flourishes like these (left). Do them as many times as you find interesting. Notice (above) that for a stroke to appear optically the same weight throughout, it must actually widen as it rises from the horizontal, through the diagonal, to the vertical. Study this illustration as well as the alphabet on the facing page to discern these subtle adjustments.

G G s R t g

Once you can execute straight and curved strokes with facility, you're technically equipped to render any alphabet you wish. But to truly appreciate the beauty of these primary elements of written speech, you must also possess a keen interest in the design, history, and heroes of typography and lettering. Here are just a few lettering examples to illustrate the enormous design potentials of this specialized art. I hope they will encourage you not to set aside lettering as a dull pursuit until you've investigated it thoroughly and discovered its hidden attractions.

It's to your advantage to know the distinct personalities of various typefaces so that you can select the appropriate one for the design and for the audience it's directed to. The job of this package, for example, is to sit on a shelf and make youngsters want to inspect it. The package must have the boldness and simplicity that appeals to children. It must shout its message in big, attractive letters. Notice that the word "yummy" reflects the type used in storybooks, and that it has the bounce and exuberance symbolic of children.

The idea of this exercise is to arrange a number of letters into a composition; moreover, the letters must spell out a name. Creating these abstract paintings was tremendous fun for me, as I hope it will be for you. I tried to make a portrait of the person I had in mind by selecting the kinds of letters which best conveyed his or her personality. Without knowing Marylin, Michael, or Judy, you can't tell if I caught their likeness, but you can certainly see that each panel reflects a distinct personality. After all, if there are musical portraits, why can't there be alphabetical ones as well? Try making alphabetical portraits of your friends.

Skill in lettering sharpens your ability to do any subject that demands meticulous and exact rendering. If you can execute a perfectly straight line or a faultlessly rhythmical curve, then you can render the symmetry of a bottle or the precision of a package with much greater ease. To prove that point, let's coordinate the related skills of painting and lettering in one picture. Begin by copying this pencil drawing.

124

Trace only the big shapes to illustration board and paint each area in flat tones of gray. Don't worry about exact contours. Paint with the biggest possible brush and see that the pigment is applied evenly; an even tone is more important than containing the paint within certain limits. No attempt should be made at this stage to blend edges; blending can be done at the final stage.

Replace your pencil drawing over the flat tones and trace all the details except the lettering. Notice there's still no blending; the areas on the bottle are just mapped out in light grays. Here I've used all five tones in F. Weber's Permogray series so that you can see their value range.

The reflections on the bottle require both wet and dry-brush blending. By this time, I'm sure neither technique presents a serious challenge to you. And if you've been practicing the ruling method I recommended, you should be able to execute the straight lines required here without any problem whatever. When you've finished the details, soften the edges of various internal planes and sharpen the outlines of shapes with white opaque. Then trace and render the lettering. If you need to correct the lettering, do so with whatever tone the lettering is rendered upon. Incidentally, compare this dainty and feminine script with the big, bold letters used on the "Yummy" cereal box (p. 122), and notice how each suits both the product and its client.

Project 22: Painting a Still Life in Color

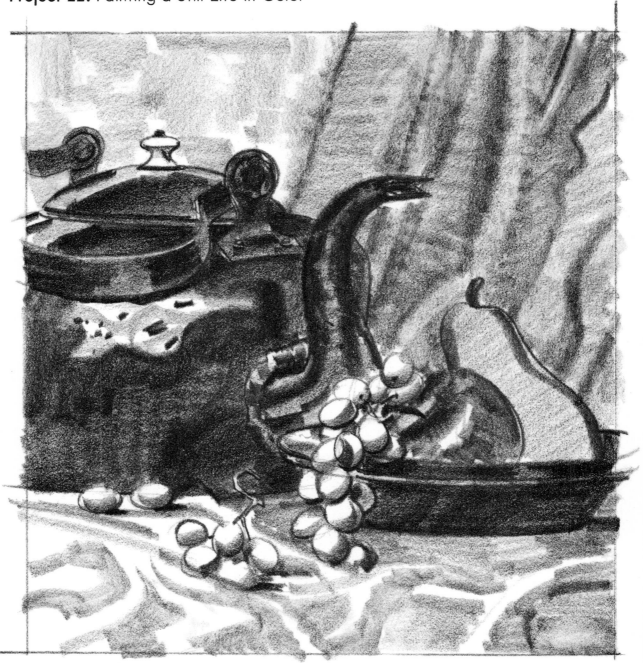

We're about to paint some "gallery" pictures. We'll still be using opaque watercolor; the same procedures will apply, as you'll see. The only difference is that we'll be working in color. This drawing of the still life we're going to paint is not meant to demonstrate pencil technique, but simply to show you that a pencil sketch is still the first step in making a picture. Its purpose, as when we work in black and white, is to establish a pleasing composition and a well organized tonal scheme. Keep these two vital factors in mind when you copy it (on thin paper so you can trace it to illustration board); and, at the same time, concentrate on the texture and value of the elements rather than on the pencil strokes used to depict them.

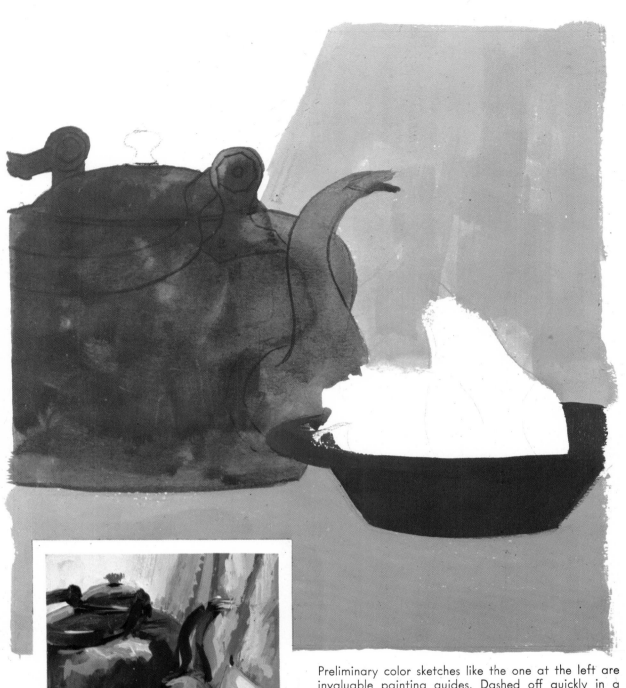

Preliminary color sketches like the one at the left are invaluable painting guides. Dashed off quickly in a small format, they allow you to experiment, to work out your color scheme, and to insure that the colors and values of your elements are correct when confined to a given picture area. What may look like a lovely still life when arranged on a table may not work within the borders of your picture. Using the final color sketch and the actual objects for reference, lay in the main elements in flat tones (above). Because of the number of planes in the composition, be sure to work from "the bottom up."

This diagram shows the relationship of the dark shape made by the objects to the gray area representing the tablecloth. I arranged the fruit to reinforce this light and dark pattern. The tilt of the pear (on the facing page) aims straight at the spout of the kettle to lead the eye back into the picture. Notice that the pear is now green since the yellow I used in the sketch generated too strong a pull toward the edge of the picture. For this same reason, I removed the apple split by the border—one more demonstration that a picture is not to be preconceived in one's mind and then set down with all its components in perfect order.

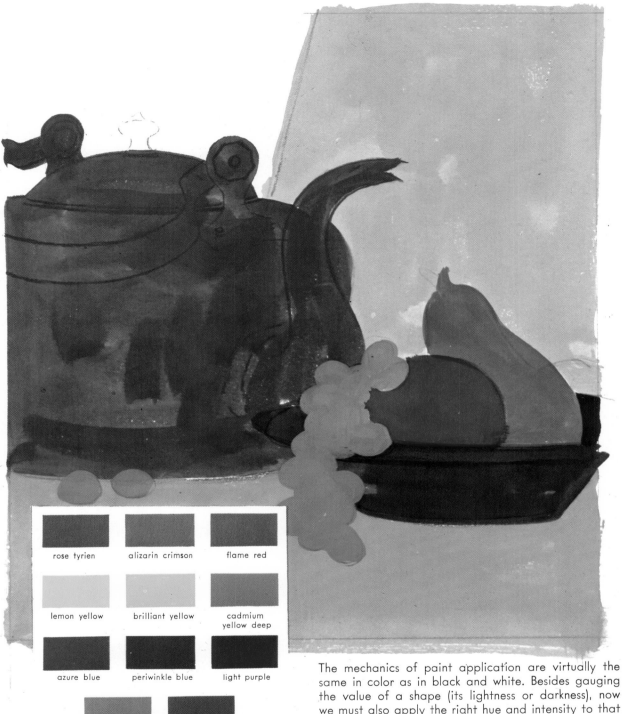

rose tyrien	alizarin crimson	flame red
lemon yellow	brilliant yellow	cadmium yellow deep
azure blue	periwinkle blue	light purple

yellow ochre	burnt sienna	
olive green	raw umber	burnt umber

The mechanics of paint application are virtually the same in color as in black and white. Besides gauging the value of a shape (its lightness or darkness), now we must also apply the right hue and intensity to that shape, that it may best serve as the middle ground for subsequent modeling and detail. Here are the pigments that comprise my palette. These colors are all made by Winsor & Newton and labeled "Designers Gouache." All are permanent except rose tyrien and azure blue (which are fugitive), and light purple (which is not completely permanent).

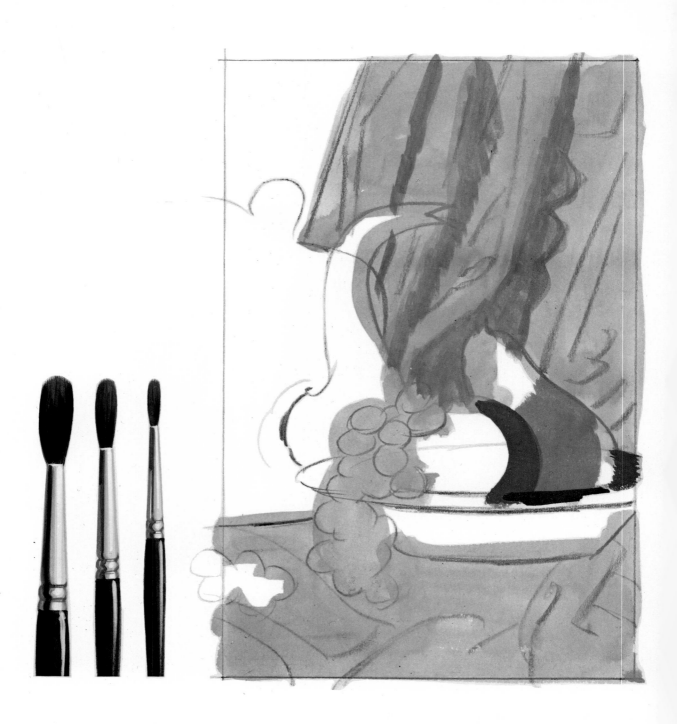

This diagram demonstrates "working my way forward," a procedure which I learned from my good friend, the great artist Austin Briggs. This method allows one to render an element "into" the contour of the one in front without having to worry about an edge twice. Note that the tablecloth has been painted beyond the edge of the kettle, the fruit, and the bowl. The pear, in turn, has been painted into the apple. The apple can then be brought back to its proper contour by rendering it after the pear, and before the grapes. The grapes—which are on top of everything—are painted last of all. The brushes used in all of these paintings are Winsor & Newton, Series 7, Nos. 8, 5, and 3. They are shown here actual size. If you feel more comfortable with Nos. 7, 5, and 2 brushes, by all means switch to them.

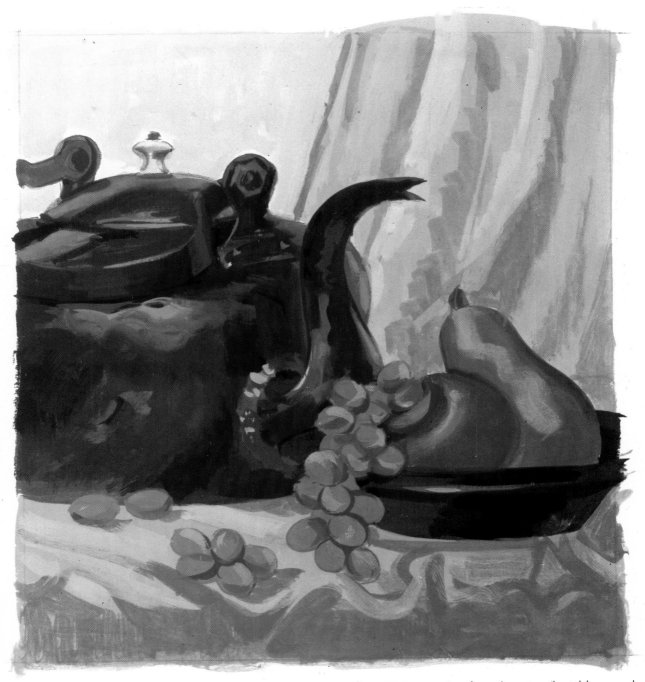

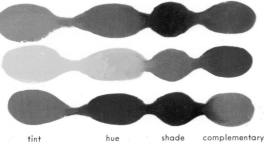

tint hue shade complementary

At this stage, scrutinize the color reproduced here and try to match it as closely as possible. In the chart at the left, color is referred to as "hue." To make a shade, add a color's complement; to make a tint, add white to it. To cool a color, add blue; to warm it, add yellow. Which blue and which yellow you use depends on a particular passage in a particular picture. There are books at the library dealing exclusively with color and its properties; get them and study them carefully so you'll have the knowledge (besides the craftsmanship) to create pictures of your own.

You've noticed, I'm sure, that I've been painting beyond the borders of the picture. There are several ways of finishing up with a neat instead of a ragged border. One (my favorite), demonstrated on the left edge of the diagram here, is to trim back with opaque white, using the ruling method. Another, shown on the right side of the diagram, is to frame the pic-

ture with masking tape and paint slightly over it. When the painting is finished, the tape is removed, leaving the neat edge shown. Still another method is to make a frame of white bond paper, with the center cut to the exact size of the picture. Use whichever procedure best suits you and your work habits, but make sure your final picture is neatly trimmed at the borders.

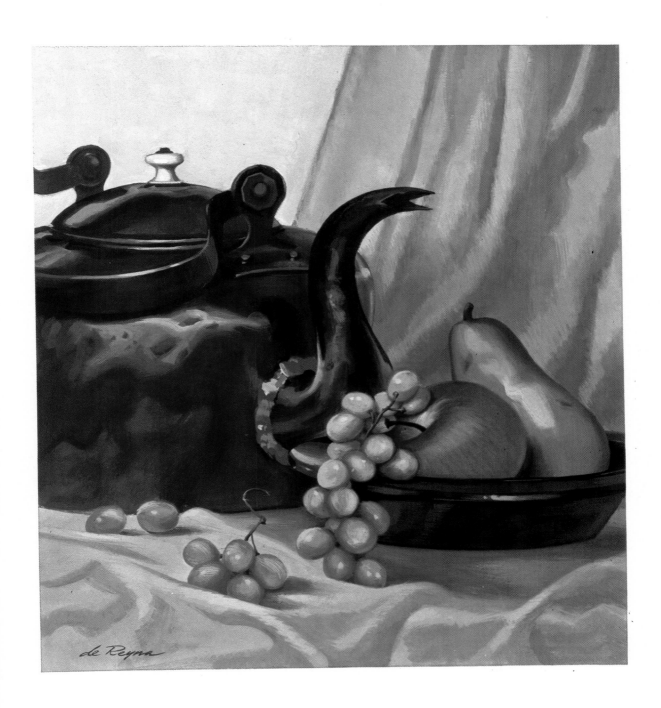

de Reyna

The work entailed in finishing this painting consisted mostly of pulling things together—defining or softening an edge, intensifying or subduing a color, bringing shadows and highlights to their proper key, and carrying the last small details to their final definition. Since my job is to demonstrate techniques of paint application, I feel I must carry things to their highest degree of finish. However, it does not follow that you must emulate this meticulous attention to detail if you are inclined to work broadly and loosely.

Project 23: Painting a Landscape in Color

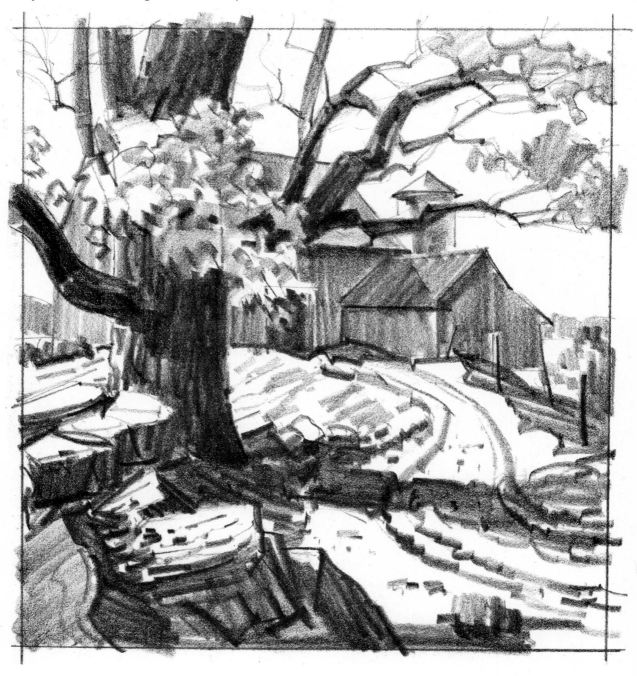

This pencil drawing was done mostly from memory and imagination, with the aid of some sketches of trees and rocks which I'd done the previous fall. The composition is quite close to the first image that popped into my mind, with the exception of the barn, which originally faced the road lengthwise, and the rocks in the foreground that were too small and made the area much too "jittery."

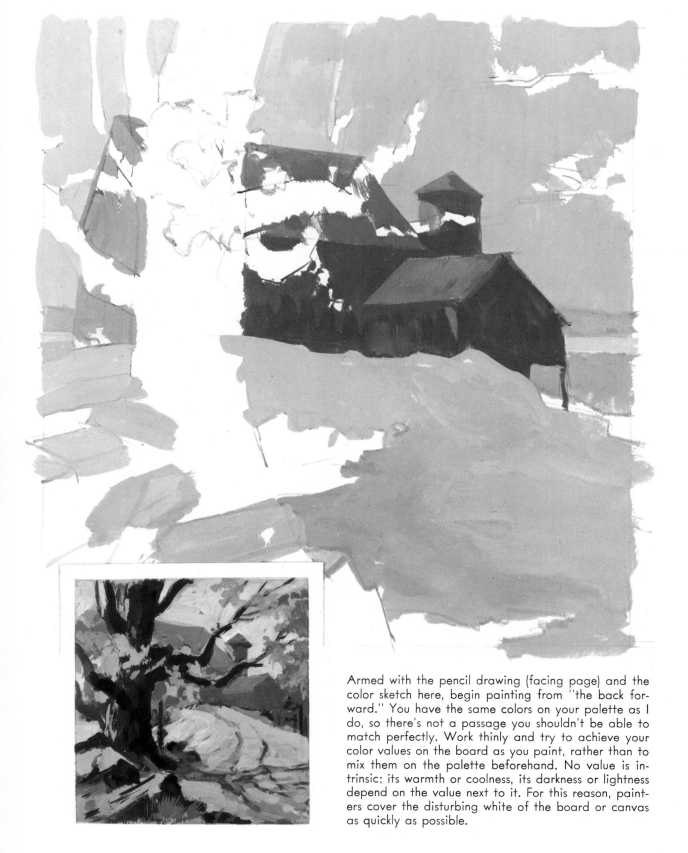

Armed with the pencil drawing (facing page) and the color sketch here, begin painting from "the back forward." You have the same colors on your palette as I do, so there's not a passage you shouldn't be able to match perfectly. Work thinly and try to achieve your color values on the board as you paint, rather than to mix them on the palette beforehand. No value is intrinsic; its warmth or coolness, its darkness or lightness depend on the value next to it. For this reason, painters cover the disturbing white of the board or canvas as quickly as possible.

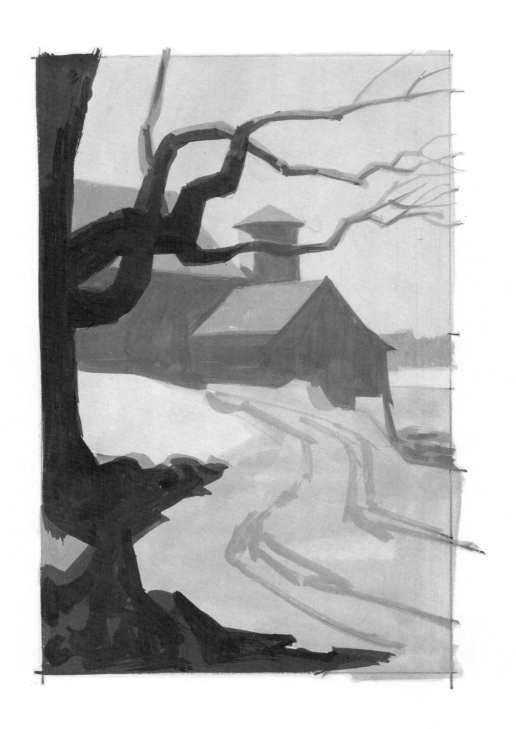

When you paint a landscape, one of the principal things to watch is the sky and how it affects the land and everything on the land. This is another way of telling you to watch the light source—its angle and its intensity. As a branch grows from the trunk and re-cedes into the picture, it becomes not only thinner, but also lighter in value, until the smallest twigs are hardly distinguishable from the sky itself. Observe this phenomenon the next time you see a tree and notice its appearance in this painting as well.

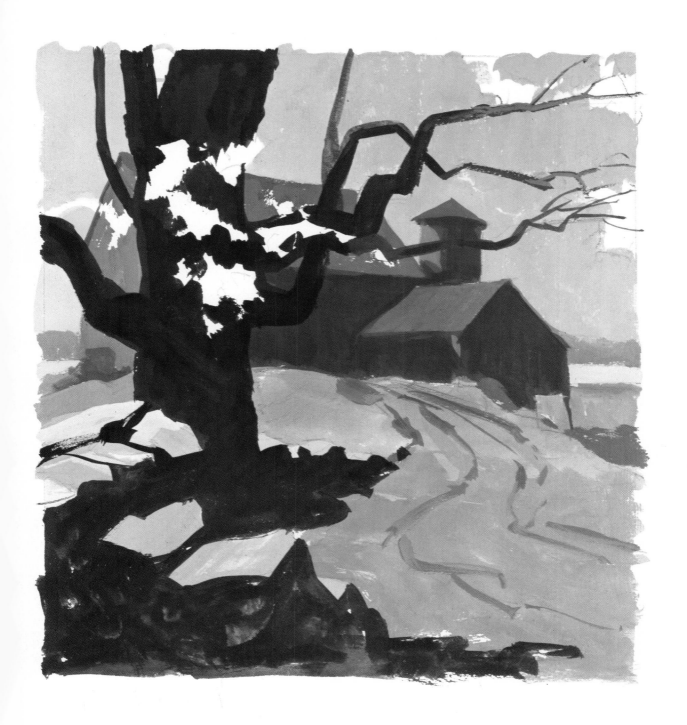

Still working our way forward (toward the front plane of the picture), we now add the tree and the stone fence. Note that the sky is lighter on the left. This is another device (besides the angle of the cast shadows) to suggest the sun is in that quarter. I have left the white paper untouched where the foliage is to be placed, not because the light pigment won't cover the dark trunk (we know it will), but because there are times when I want the luminosity of white showing through rather transparent pigment. In this instance, the white paper will be covered with the transparent yellows of the autumn leaves.

Just a reminder here that no area in your picture should be covered with the kind of flat and even coat of paint that you see in the upper panel. Rather, the paint should be worked thinly and vigorously in all directions, as it is in the lower panel. This technique has the vibrancy to convey the life and vigor of nature.

Another advantage is that if we want to sponge off an area, it's much easier to pick up a thin layer of paint rather than a thick coat of paint. Remember, too, that the first lay-in will be covered by subsequent layers of pigment as we search for the right color value or texture.

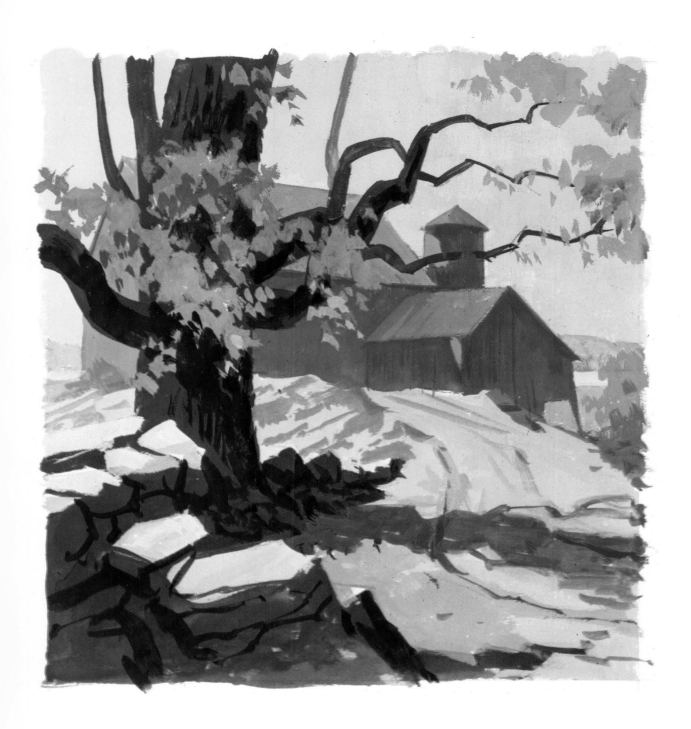

The pencil drawing and the color sketch that you duplicated in the previous stages should be on your drawing board for constant reference. By the time you reach this stage, you can relax and enjoy adding the finishing touches that will turn this lay-in into a glimpse of nature. Actually, a few more touches on the rocks and the tree for added character, and I would pronounce this landscape finished. Note the pervading blue-violet in the entire picture to complement the yellow-orange of the foliage.

The purpose of this diagram is to heighten a perspective principle that may already be quite obvious to you in the work on the opposite page; but I shouldn't want to take the risk of your missing one single point in the making of pictures. The illusion of depth on a two dimensional plane is achieved by overlapping gradually darker and darker shapes as they advance to the foreground. As you work, be aware of this spatial principle; you may use it or discard it as your future subjects require.

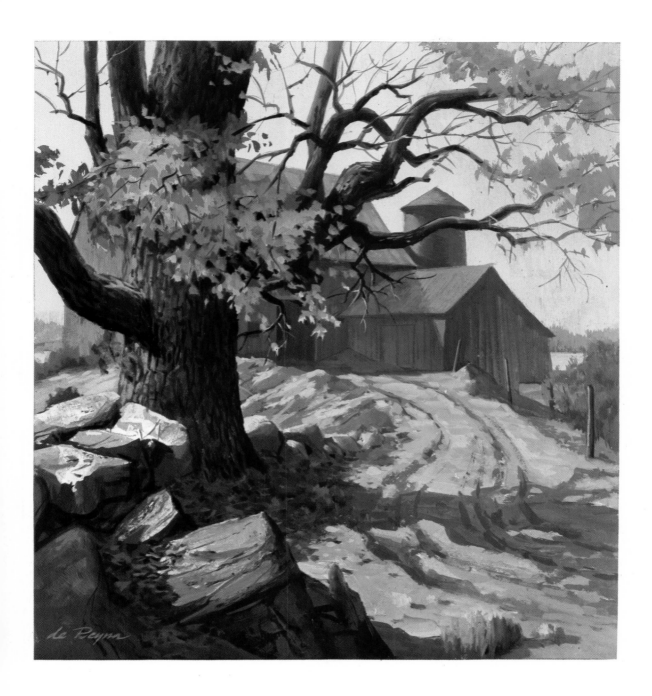

The final stage in any picture consists of adding small details. This process is considered the "dessert" by most of us because it's so much fun to do—and therein lies the danger. It's easy to overdo the details and to end up with a catalogue of objects instead of a well-knit, analogous unit. So keep a close watch on your own work in the final dressing up. Here I applied a white impasto with a palette knife to the light areas on the rocks (up to the tree). Then I tried to form ridges and hollows with the knife, intending to articulate them better when applying color later with the brush. Finally I worked on the branches and the road, adding lights and shadows and carefully rendering final details, while the impasto dried completely.

Project 24: Painting a Figure in Color

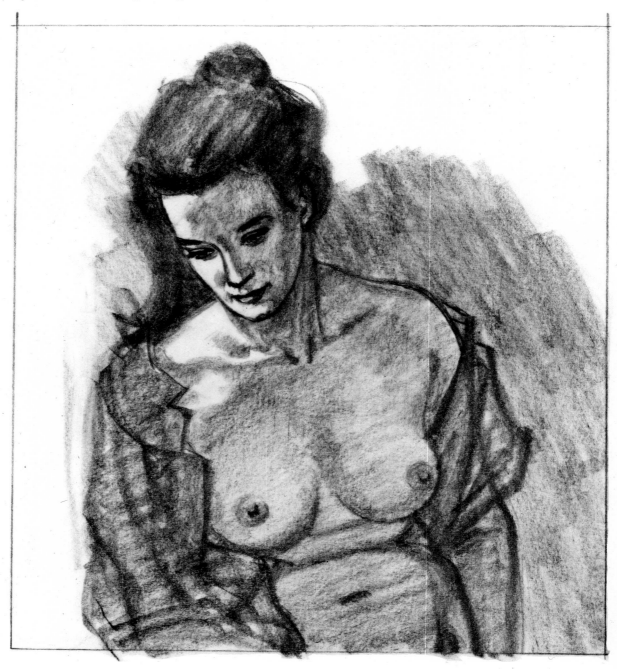

As I worked on this drawing, I thought of all the nudes and semi-nudes I had seen on canvas and on the dais in the academy—of Rubens and his voluptuous ladies; of David and Ingres and their cold, clinical approach to the female body; of Goya and his Maja; of Velás-quez and his only nude (and I wondered who the lady was whose face he purposely blurred in the glass held by the cupid). I was lost in all sorts of remembrances, but at the same time my craftsman's mind was constantly alert; and I found myself automatically approving a line here and rejecting another there as I drew, until the model asked if she could "take five."

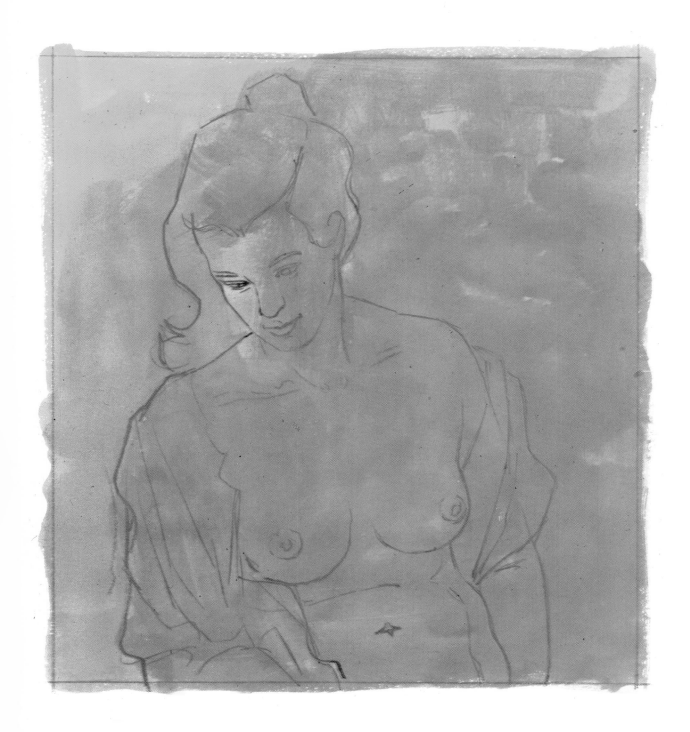

It occurred to me that this particular girl called for a color scheme of pinks and soft grays, an over-all high key, with no deep notes. So clear was my image of the over-all tonal scheme, that I felt free to begin painting without the aid of a color sketch. I quickly traced the drawing, reinforced the line with pen and ink, and gave the entire area a thin coat of pink. The effect was just what I wanted!

Again let me suggest that you read the entire exercise before you begin to work. Here are two ways of starting the painting: the top panel shows the traced drawing, with the paint applied thinly over it. The second panel was painted first, and the drawing then traced over it. You can follow the second procedure when the painting carries a pervading color (pink in this case) or when you plan to work over a definite undertone. I chose the first method out of habit, I suppose, since the second seems more logical by far.

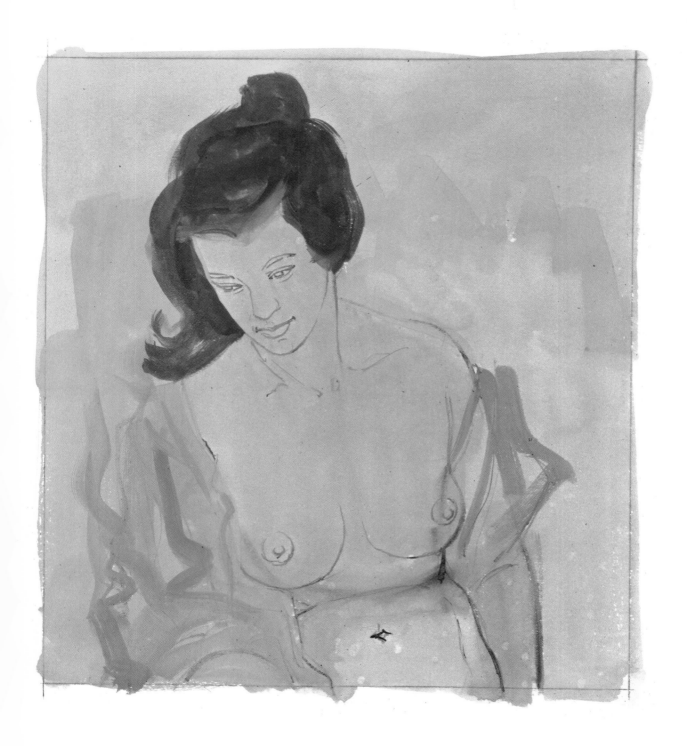

In this stage, I picked up a bit of burnt umber and a whisper of olive green, and then dipped a No. 5 brush into the puddle of pink which was still wet on my tray. I tested the charged brush on a piece of scrap paper and found it was too dark. To lighten the value, I brushed off some of the pigment on the tray and dipped again into the pink. This adjustment gave me the exact color I wanted for the hair—a note just dark enough to relate to the rest of the figure in the soft modeling I'd envisioned from the start.

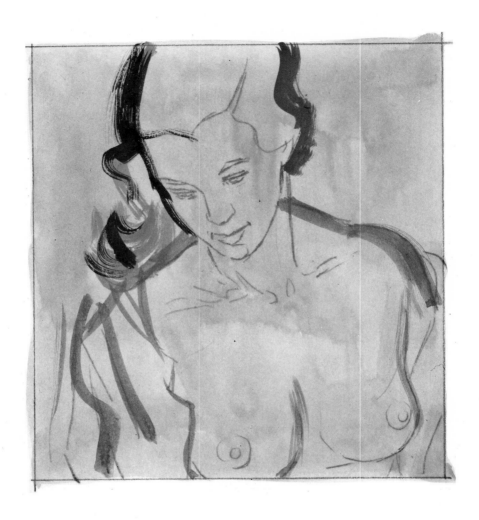

It would make me very happy if I knew that you're enjoying these exercises—that you're completely relaxed and having fun. There's nothing to be apprehensive about. If something doesn't quite come off, you can chalk it up to experience; whatever turns out successfully, you can display with pride. So loosen up and paint with the directness born of self confidence. The purpose of this illustration is to show you how to work freely and broadly. As you indicate an edge or a fold, let your stroke be loose and spontaneous, as mine is here. You can always "clean up" later and be as meticulous as you wish.

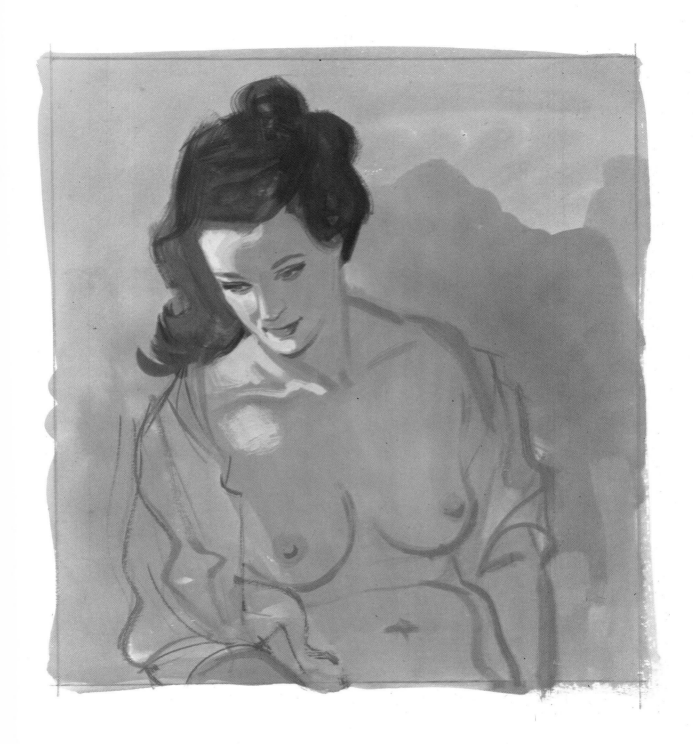

Once more we arrive at a complete (if not finished) picture, one that satisfies my aesthetic sense. (What other sense can the artist stand upon?) The painting is a symbol of lovely womanhood, not a copy of my particular model. It is evocative and stimulates the spectator to thought or reflection without the circum-scription of a literal statement. But Allah in Heaven, what I'm saying has no bearing whatever on the mere mechanics of paint application. Very well, let me then say that since the pervading color is pink (tint of red), I shall now dip more and more into its complement (green) for the modeling that is to follow.

To my mind composition is one of the most important components in picture-making. A painting can be masterfully executed; its subject can be lofty; it can have a thousand praiseworthy elements. But if the composition is wobbly, it can fall flat on its gilded frame. Both by linear thrust and by tonal contrast, the accent in this painting is the girl's head. I kept this fact constantly in mind as I painted the background and the rest of the figure. As you work, be aware of one focal point and remember to subordinate other elements to it—no matter how complex your subject turns out to be. Your composition may contain a secondary point of interest, but always lead the viewer's eye first to one predominant spot.

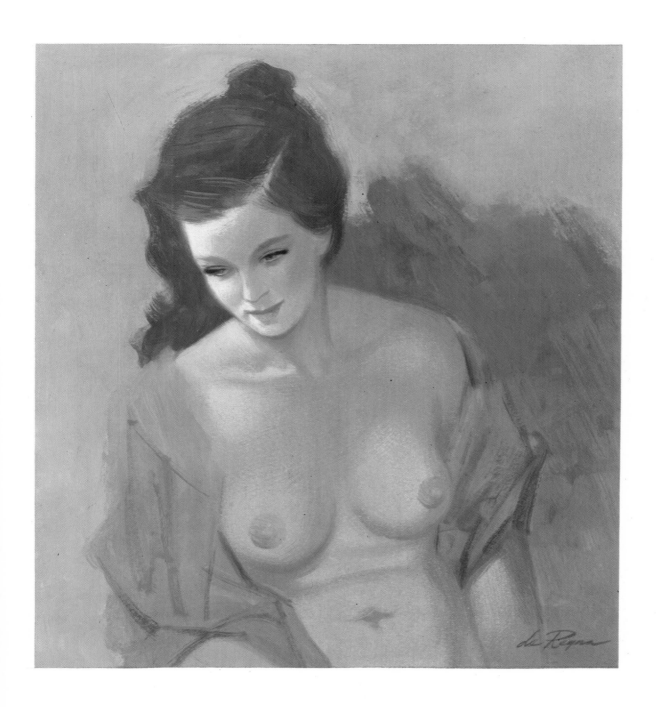

The figure was modeled with a drybrush in tints of olive green, over which I drybrushed the background pink, deepening and lightening it as required. This weaving together of the subtly complementary colors gave the entire painting the unity and oneness I wanted to preserve from the previous stage. Notice that the gray on the robe is not a neutral gray (as you can see if you compare it with the diagram on the facing page), but that it's made up of tints of violets, blues, and greens.

Project 25: Painting a Portrait in Color

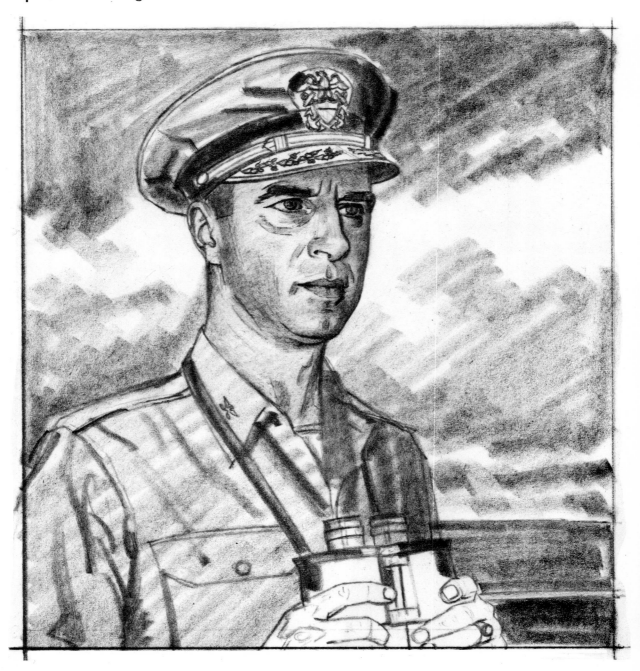

I've kept the portrait for the last exercise because I consider portraiture the most difficult genre of painting. There are a thousand opinions on the subject from both artists and the public. An individual will accept a painting of any subject without greatly questioning the artist's intention, but let that same person be the subject of a portrait, and by george you'd better be prepared to defend each and every one of your brushstrokes to him. With that dire warning in mind, pluck up your courage and try this pencil sketch.

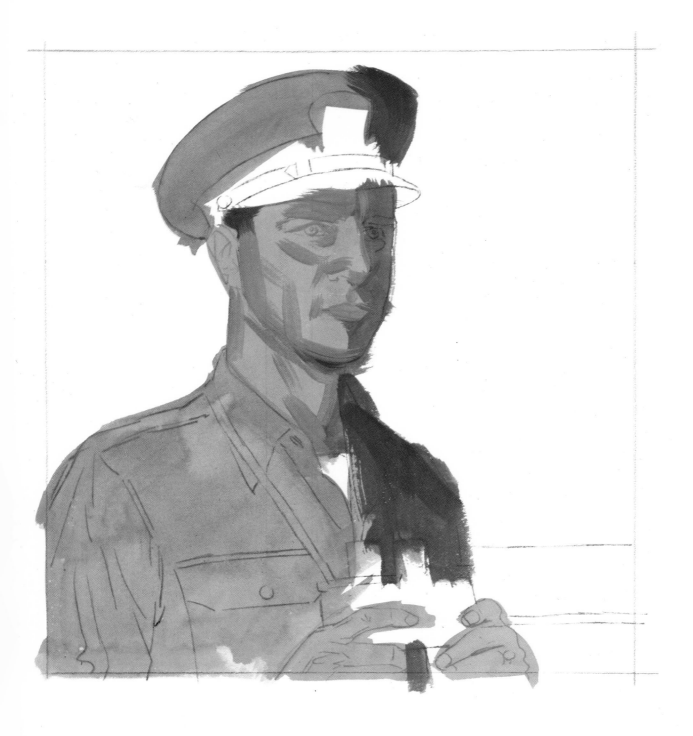

If I'm no longer giving you detailed explanations of the preliminary pencil stage and the first lay-in, let it be a tribute to you and your intelligence. Actually, I feel confident that in this last exercise I could have done just the finished painting and have let you follow the necessary steps toward its completion on your own. But then I thought, "why not explain the problems I myself encountered?" By sharing my experience, I may help you avoid the problems I encountered and let you come up with a few of your own!

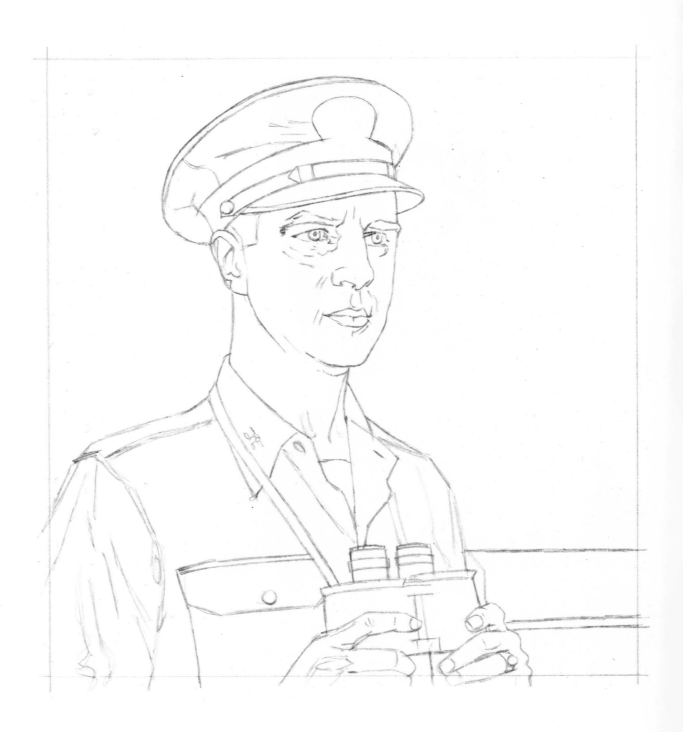

This is the tracing I made before applying the paint on the preceding page. Notice that again there's no color sketch to guide us toward a color scheme. In the painting of the nude, a color sketch was unnecessary since it was envisioned from the start as a pervading pink. Here I knew that the black, gold, and tan of the uniform would dictate the color and mood of the background. So, as you noticed, I started right in with the flesh tones and the tan uniform.

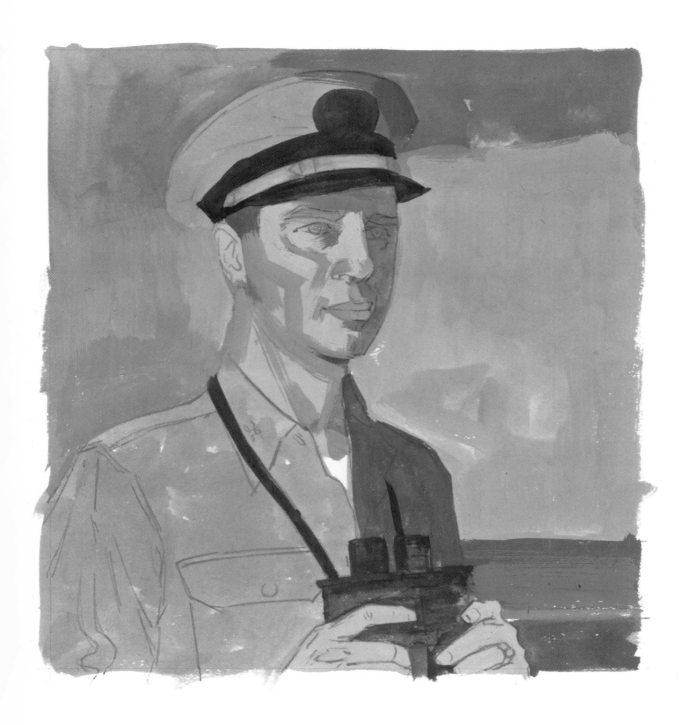

Why not make the background a stormy, threatening sky? This, I thought, was an inspiration! After all, a military man is supposed to know no other. Besides, this concept gave me the chance to use a symbolic battleship gray! "Rudolf," I said to myself, "you're a blasted genius. Blushing unseen, but still a genius!"

As I proceed, I'm glad I decided to demonstrate every stage of this final exercise. I might otherwise have forgotten to pass on this bit of information about the details of the officer's cap: when you trace on white paper, you naturally reach for the graphite stick and proceed to rub the back of the drawing. But how do you go about tracing a drawing or a detail onto a dark ground? I encountered this problem in adding the light details onto the dark peak of the cap. Instead of using graphite, I rubbed chalk (white pastel works as well) on a tissue, which I used as my transfer paper to trace the insignia on the hat.

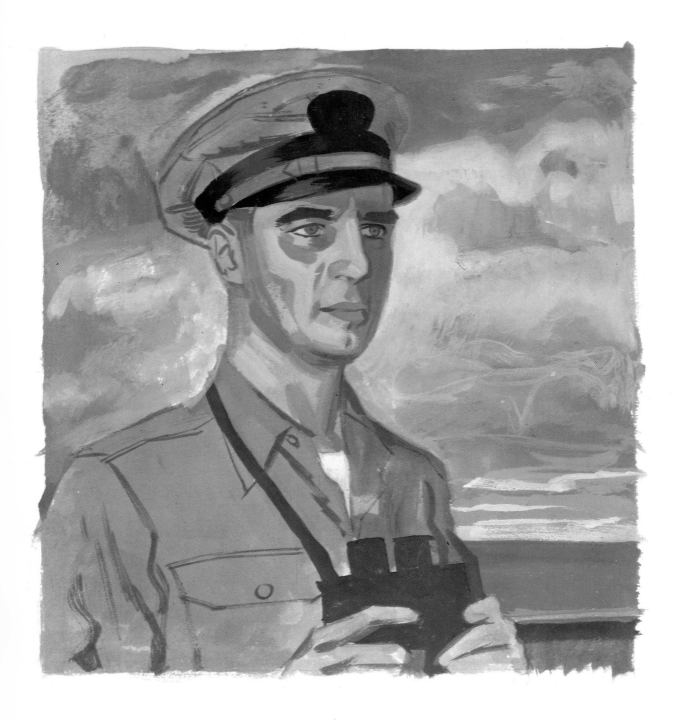

Pursuing my inspiration about the sky, I thought I'd make it a really stormy one to strengthen the symbolism of the rough seas in a sailor's life. And then it happened; I made it so boisterous that it detracted from the Captain's head! And that would never do in a portrait. So I worked on the hat and the face to see if I could make the head dominate, the sky calm down and recede; but it was no use.

Suddenly I realized that my focal point was being disturbed by another element entirely. The black binoculars on the bottom edge were pulling the eye downward, in spite of the strong horizontals that should have led it upward as the diagram above explains. I had no choice but to kill the black and render it in grays, including the strap going up round the neck. Perhaps I should have prepared a color sketch.

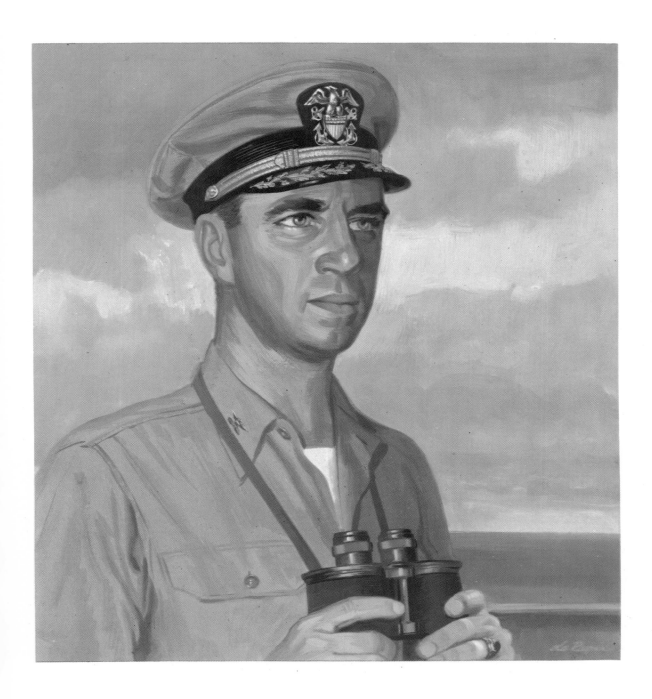

I've intentionally left myself a very small space for the last words of parting because I've always hated prolonged goodbyes. We've worked our way together through a hundred and fifty-odd pages. My fervent hope is that you're now a better artist, and that whatever you paint in the future will be more eloquent and moving because this book inspired you to it. Goodbye and all the best to you, my dear friend.

Index

Alphabetical portraits, 123
Animals, anatomy of, 70; sketched from nature and photographs, 70; see also Cats; Dogs; Horses; Lambs
Book illustration, children's, 104-111; and color restrictions, 104; and line drawing, 104; with toned paper, 106
Branches, 138
Briggs, Austin, 132
Brushes, general discussion of, 12; for still life, 132; size of, 146; illus., 13
Brushstrokes, broad and loose, 148; flat and vigorous compared, 140; see also Drybrush; Lettering; Splitbrush
Butcher's tray, see Palettes
Carbon sheets, 97
Cast shadows, 139
Cats, 76-81
Children, 96-111; as subjects in book illustration, 104-111; cultivating simplicity in drawings of, 110-111
Clouds, 36; illus., 37
Color, 128-159 passim; and hue, 133; and shade, 133; and tint, 133; and value, 26; brands of compared, 12; complementary, 133, 141, 149, 151; in author's palette, 131; mixing of, 133; permanence of, 131; warm and cool, 133
Color sketch, 127-159 passim; of landscape, 137; of still life, 129; purpose of, 129
Composition, and color, 130; and memory, 136; focal point in, 150, 158; subordination in, 150, 157
Contour, 132
Crayon, white wax, 140, 146; illus., 38
David, Jacques-Louis, 144
Dental tools, 38, 49; illus., 49
Designer's colors, see Opaque watercolor
Detail, 135, 143; tracing of light onto dark ground, 156
Dogs, 74-75
Dorne, Albert, 12-14
Drawing boards, 12; see also Papers and illustration boards
Drawing Lessons from the Great Masters, 62
Drawing the Human Head, 62
Drybrush, 67, 68-69, 73, 75, 79-81, 92, 94, 127, 151; compared with splitbrush, 68; technique of, illus., 30-31
Dynamic Anatomy, 62
Famous Artists Schools, 14
Feathering, 68; to soften drybrush, 81
Finishing, of picture borders, 134
Flesh tones, 65
Folds, 86-95, 102; and underlying form, 86; as three dimensional form, 86; bulk and volume of, 88; construction of, 86; relationship of pattern to, 86; tracing of, 90
Foliage, see Trees
Frisketing, 44-49 passim; illus., 44-45
Frisket knife, illus., 38
Gouache, see Opaque watercolor
Goya, Francisco de, 144
Graded tones, 22-23

Grass, 24; illus., 25
Gray, warm and cool compared, 12; see also Color; Values
Hair, 68-69, 147
Hale, Robert Beverly, 62
Heads, 50-61; female, 54-61; male, 51-53
Helck, Peter, 12, 38
Hogarth, Burne, 62
Horses, 70-73
How to Use the Figure in Painting and Illustration, 62
Hue, 131
Illustration boards, 14-15; see also Papers and illustration boards
Impasto, 143; as underpainting, 48; scraped for unusual effect, 39
Ingres, Jean-Auguste-Dominique, 144
Lambs, 82-85; wet blending in, 84
Lamps, 14
Landscape, 136-143; see also Clouds; Rocks; Sky; Trees; Water
Lettering, 112-127; and packaging design, 122; as element in painting or illustration, 124-127; examples of, 120-121; flourishes in, 119; optical illusion in, 119; ruling method for, 114-115, 117-118; selecting appropriate, 122; straight and curved strokes in, 118-119; as abstract paintings, 123
Lighting, 51
Light source, 138-139
Line, 104-111 passim; combined with tone, 105-109; for children's book illustration, 104-111; on toned paper, 106; to render pattern, 105
Mahlstick, 73
Masking tape, 38-39; to trim picture borders, 134; illus., 39
Matisse, Henri, 10
Modeling, of forms, 11
Nudes, 62-67, 144-151
Opaque watercolor, advantages of, 10; behavior of, 11-12; compared with oils, 10; with transparent watercolor, 10; definition of, 11; density of, 11; thinning of, 11-12; versatility of, 11
Overlapping, 144
Painting from the back forward, 132, 137, 139; illus., 132
Painting from the bottom up, 36, 129; illus., 36-37
Palette knife, 38; as unconventional tool, 42; to apply impasto, 39, 143
Palettes, 14; illus., 13
Paper stump, 38; as unconventional tool, 42
Papers and illustration boards, 14-15; blotting paper, 61; colored mat boards, 77; experimenting with for different effects, 58-61; gesso panel, 59; gray charcoal paper, 60; influence of on paint, 58-61; mounting board, 55; paper skin canvas, 61; pebbled mat board, 59; shirtboard, 58; showcard, 55; toned paper, 77
Pattern, 86-95 passim; and composition, 130; checkered, 87, 89, 93-95; relationship of to folds, 86; used for liveliness, 102; tracing of onto folds, 89-93; values of gray in, 94-95
Pen and ink, 145
Pen compass, 43, 47; illus., 38

Pencils, 52, 55; to reinforce drawing, 55
Pencil drawing, from nature, 32; from photographs, 32; purposes of, 26, 32, 71, 128; size of, 26; tracing of onto illustration board, 26, 32
Perspective, 142
Photographs, 32; quality of, 82
Picasso, Pablo, 10
Pick-up eraser, 44
Pipe cleaner, 44
Pitz, Henry C., 62
Portraiture, 152-159
Razor blade, 39, 59; illus., 39
Reflections, 126
Registering overlays, 93
Reinforcing details, with pencil, 53; with pen and ink, 100
Rocks, 32-33; illus., 33
Rubber cement, 44; for unusual effects, 42, 47; illus., 47
Rubens, Peter Paul, 144
Ruling method, 114-115, 117-118; to finish picture border, 134
Ruling pen, 43; illus., 38
Scale, 54
Shade, 18
Sky, 138, 155-156
Softening hard edges, 91
Spattering, 39; illus., 39, 44
Speedball pen, 43, 48; illus., 38, 48
Splitbrush, 68-69
Sponges, as unconventional tool, 41, 44; to apply sky, 49; to create texture, 49; to remove paint, 140; illus., 38
Steel wool, 44
Still life, 128-135
Tabourets, 14
Texture, 51
Tint, 18
Tissue paper, as unconventional tool, 41, 46, 49; illus., 46
Tones, flat, 17; graded, 24-25; gray, 55; intermediate, 20, 28
Tonal scale, 50
Toothbrush, as unconventional tool, 39; illus., 38; see also Spattering
Trees, 26-29; illus., 27-29; see also Branches
Trimming, with white, 31
Unconventional tools, 38-49 passim
Underpainting, 22; see also Wet blending
Values, 18-21, 24-25, 26-29; and color, 131; definition of, 18; lightening of, 18; matching of pencil in opaques, 26; middle, 26; mixing of, 18-20; relativity of, 137; rendering light and dark, 26; scale of, 20; see also Color
Vignette, 108
Velásquez, Diego Rodríguez de Silva Y, 144
Wash, 10
Water, 34-35
Wet blending, technique of, 22-23; as underpainting, 22; to render lamb's wool, 84; to render reflections or glass, 127
Wooden roller, as unconventional tool, 40; in frisketing, 44; illus., 38, 45
Wooden shingle, for unusual textural effect, 40, 47; illus., 47